D1206953

ZALMAÏ

DREAD AND DREAMS

Daylight

Cofounders: Taj Forer and Michael Itkoff
Design: Ursula Damm
Copy Editor: Elizabeth Bell

ISBN: 978-1-942084-02-0

Printed in Italy

Daylight Books
E-mail: info@daylightbooks.org
Web: www.daylightbooks.org

For me, the story of Afghanistan starts in 1980. I was a teenager in Kabul, forced to leave the country after the Red Army invaded. When I went back in 2001 to cover the fall of the Taliban for *Newsweek*, I found an Afghanistan devastated by war, pain and poverty, forgotten by the international community. Who was *this* war against, I wondered. It wasn't the first. The country had been through war after war.

After the Taliban fell, there was a period of great hope. You could see it in people's eyes. I found it in the light and the shadows, day and night, in the air. It felt like my country had awakened from a nightmare. I photographed that hope. It was significant. I wasn't in Afghanistan to take pictures of the fighting, the soldiers, the planes, the tanks, the Hollywood movie. I was there to see the Afghans.

But the hope in their faces started fading away. That light was dying. With the Western intervention, Afghanistan's reality—its needs, its

history, everything that makes it Afghanistan—was forgotten. The military option was the only one ever considered. Remember, Afghanistan was in this condition because it had been invaded and abandoned. We were trying to heal the disastrous consequences of an invasion with another invasion.

Billions of dollars were poured into the military "solution." And this solution became part of the problem. More soldiers were sent to destroy a country that was already devastated. Troops were fighting terrorism in tiny villages without seeing the larger sources of the problem. More and more civilians were killed; more and more mistakes were made. There was no understanding, no long-term view.

I looked at what this "war on terror" did to people's lives. I didn't focus on corpses, blood and violence. I photographed the silent war, far from the front lines, where people die of hunger, sickness, exile and fear, in the farthest corners

of the country as well as the big cities. I spent time with people going about their daily lives.

My work is not about war, but war is in my work. And this is the core of my photography: ordinary moments turn out to be extraordinary. As extra-ordinary as any battle. My hope is to pay attention, to expose meaning in moments that otherwise pass unnoticed, to put a color on the dream of a simple life, in peacetime. We have to look at both the destructive force and the life force. They always clash, but the life force wins eventually.

—ZALMAÏ

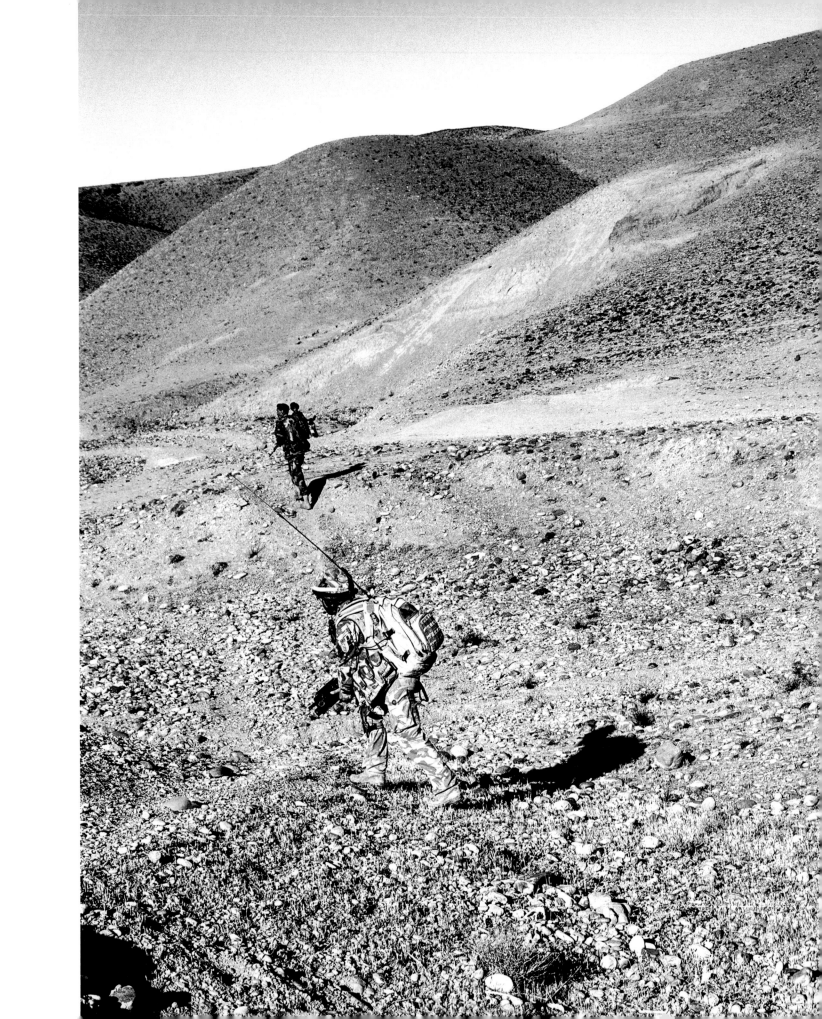

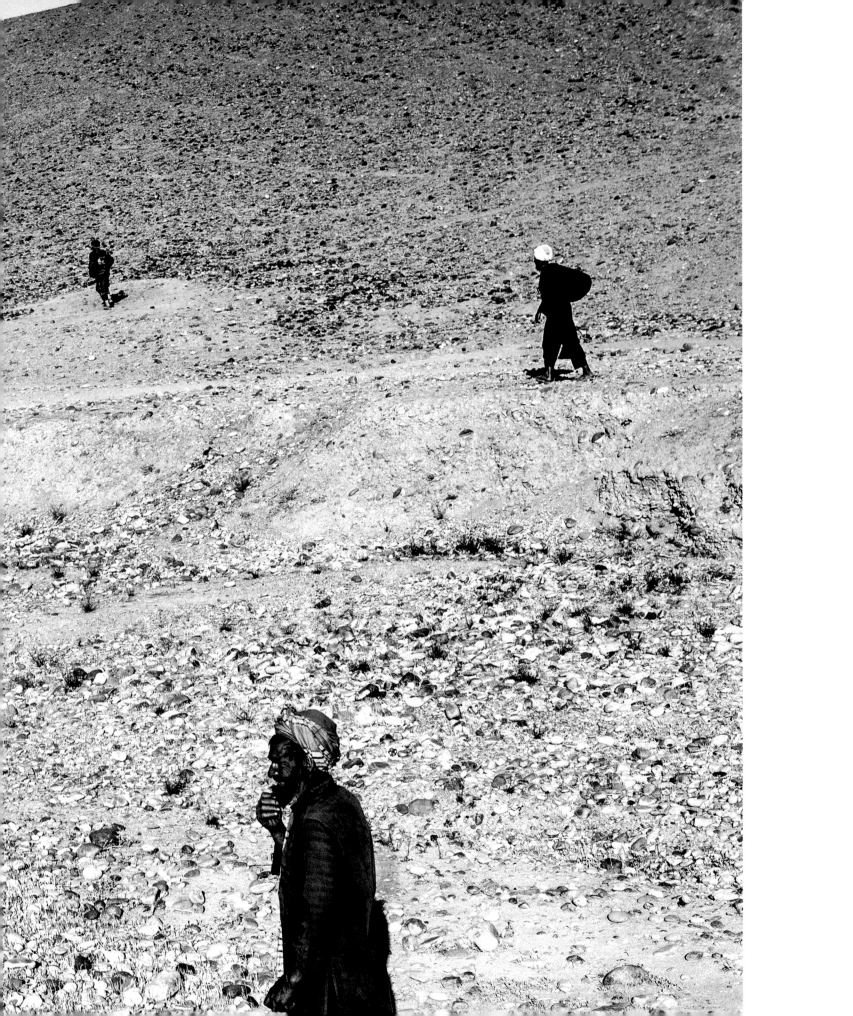

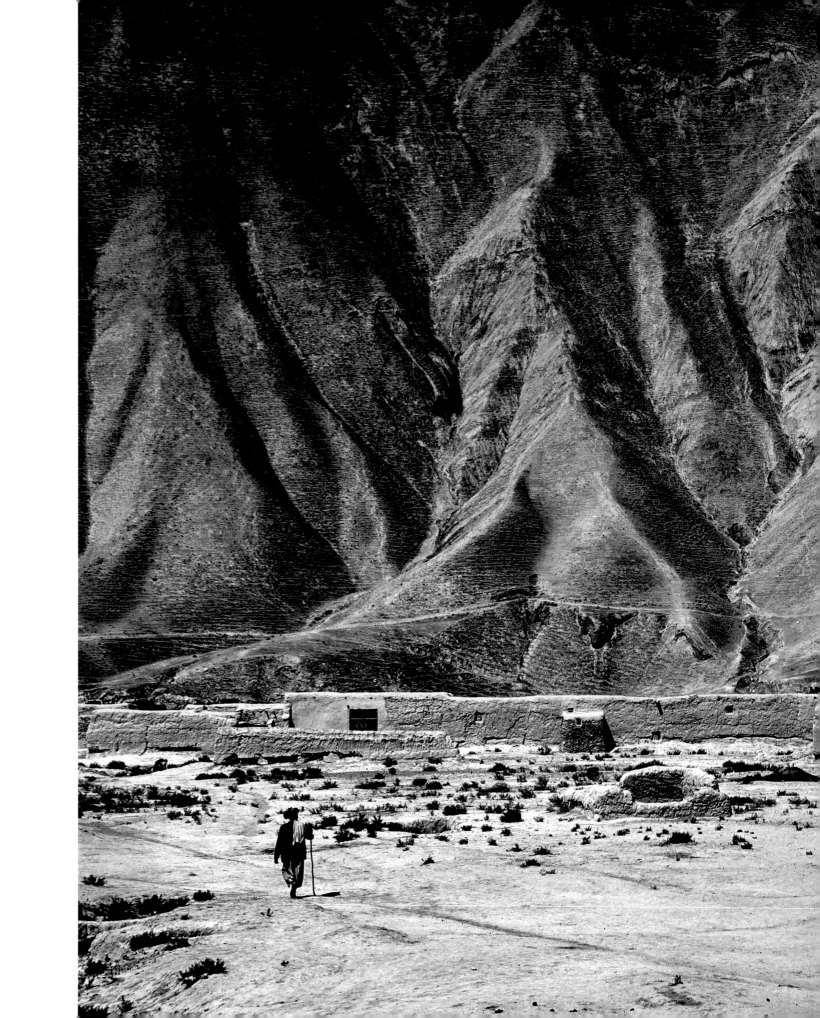

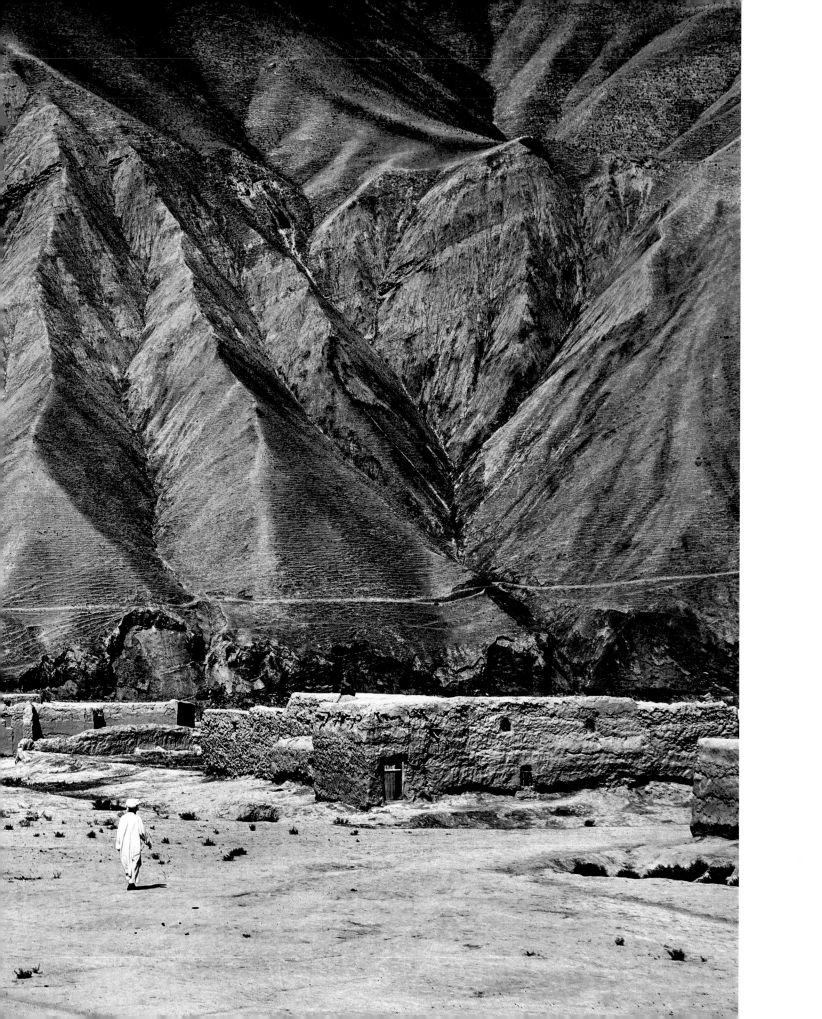

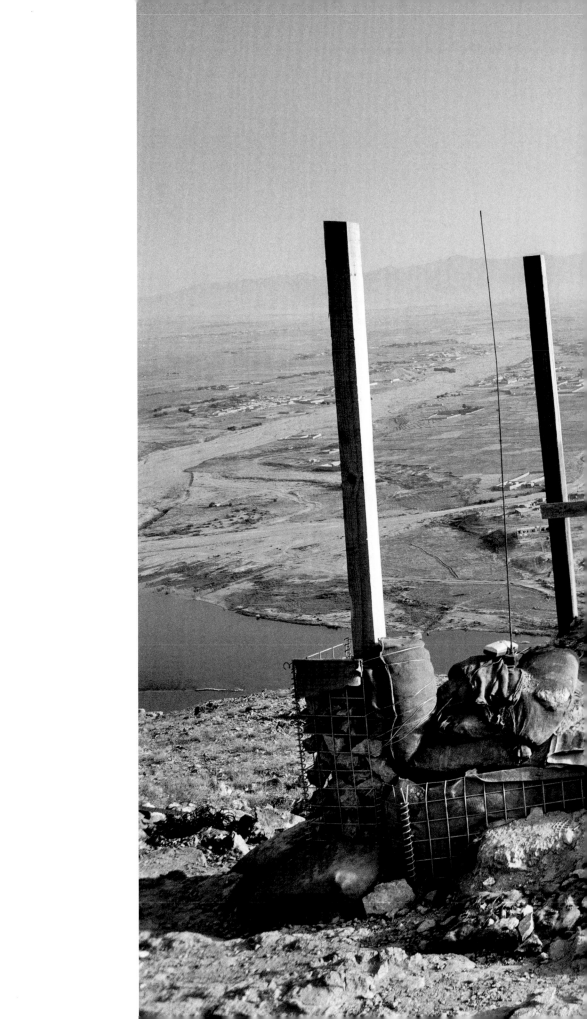

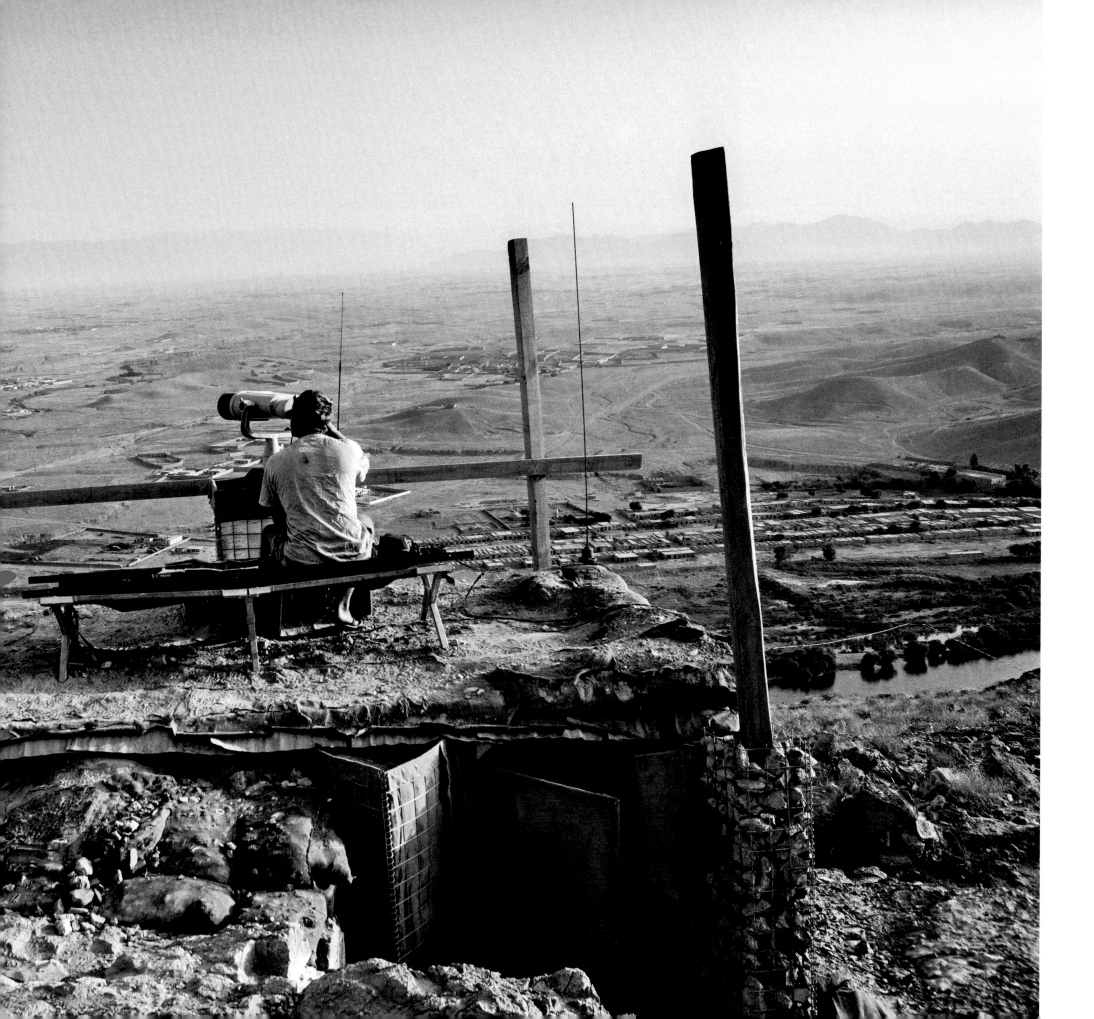

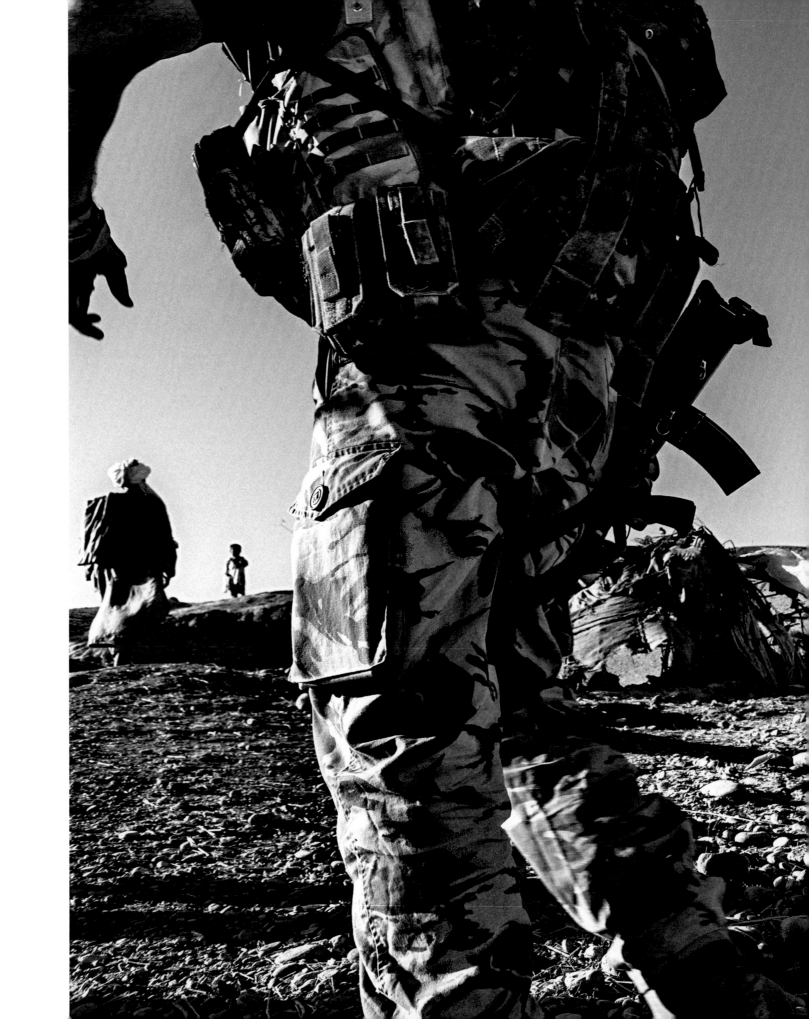

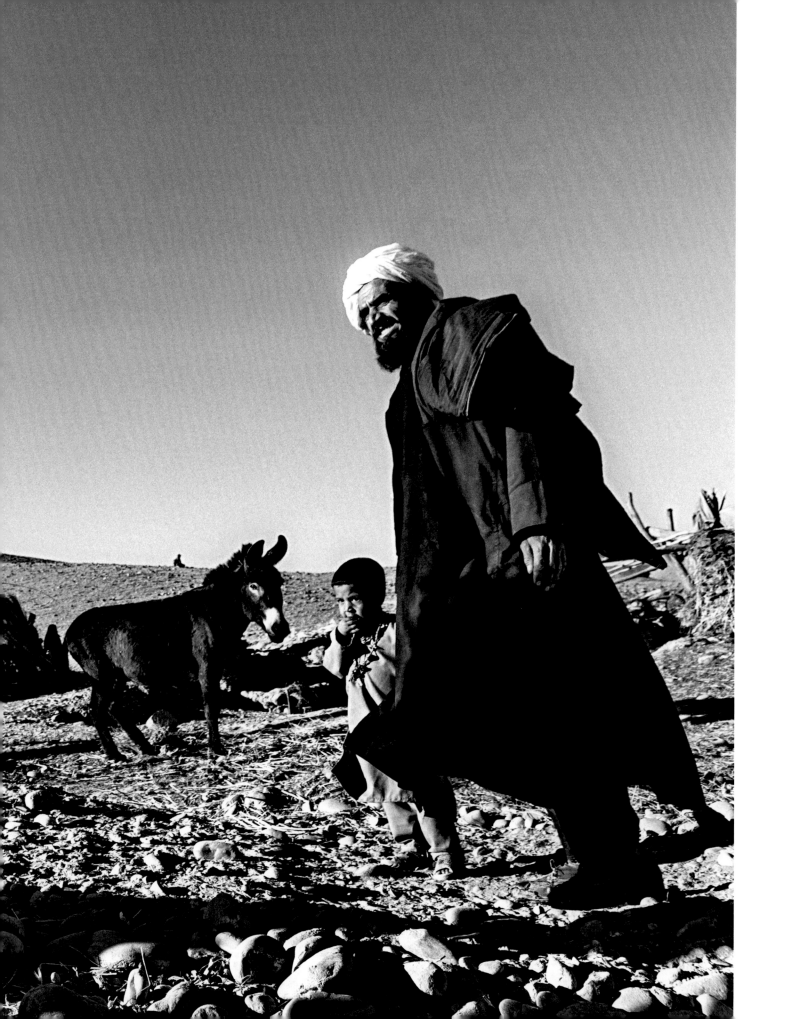

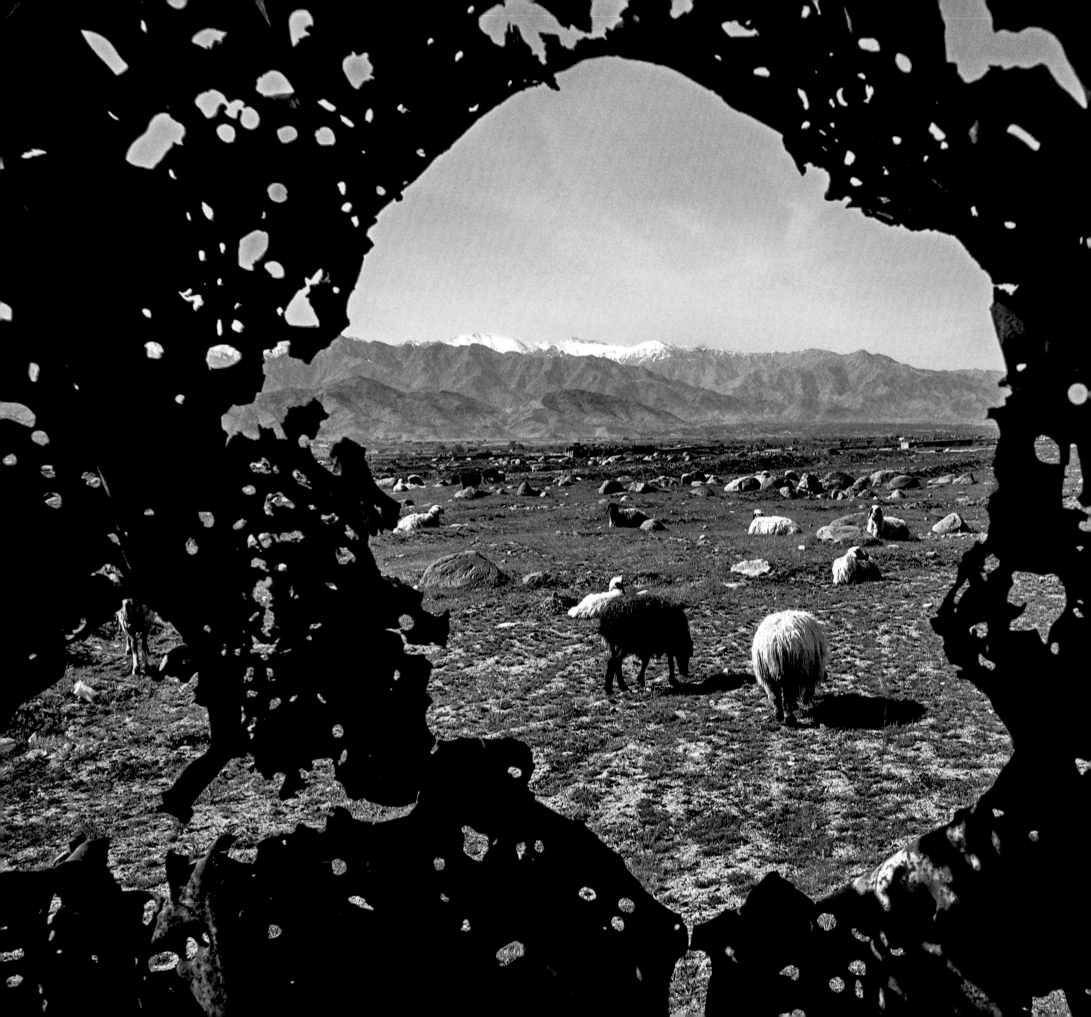

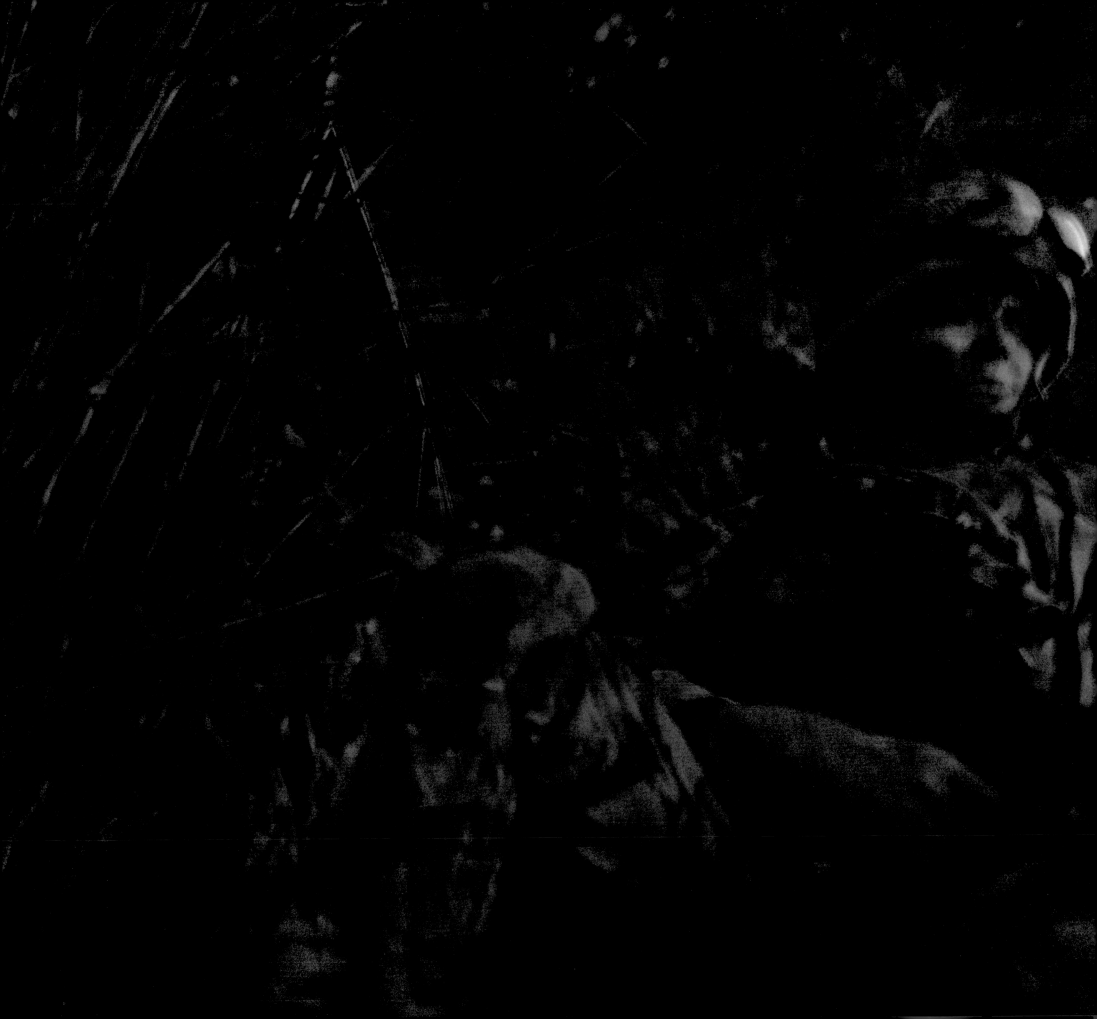

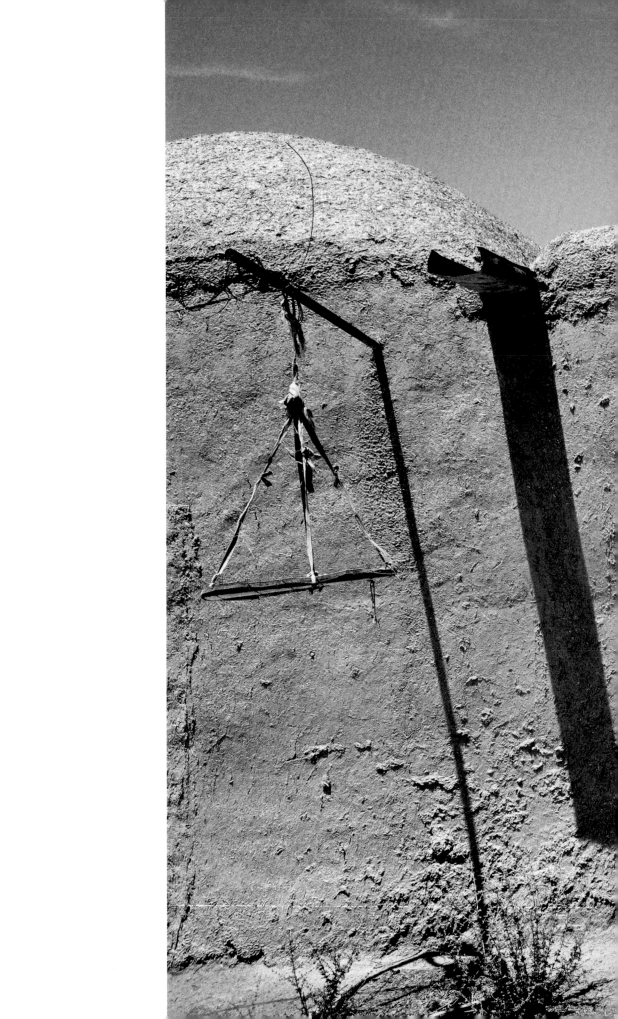

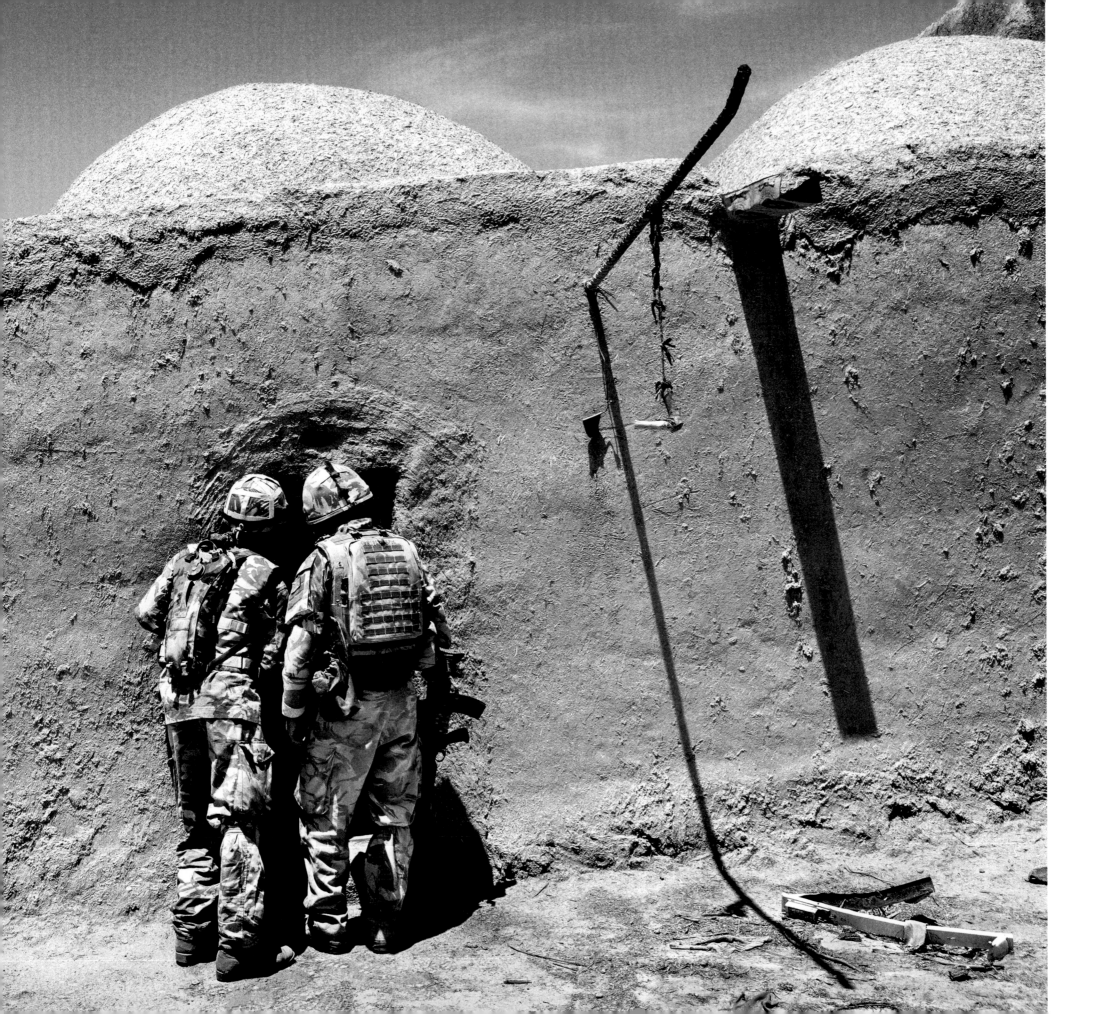

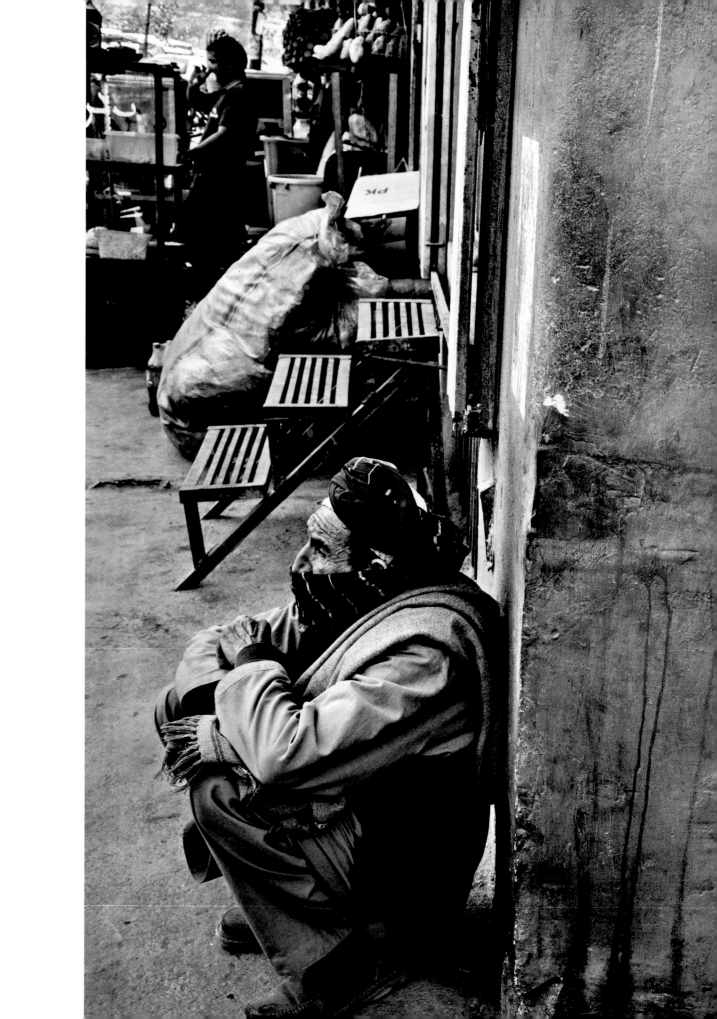

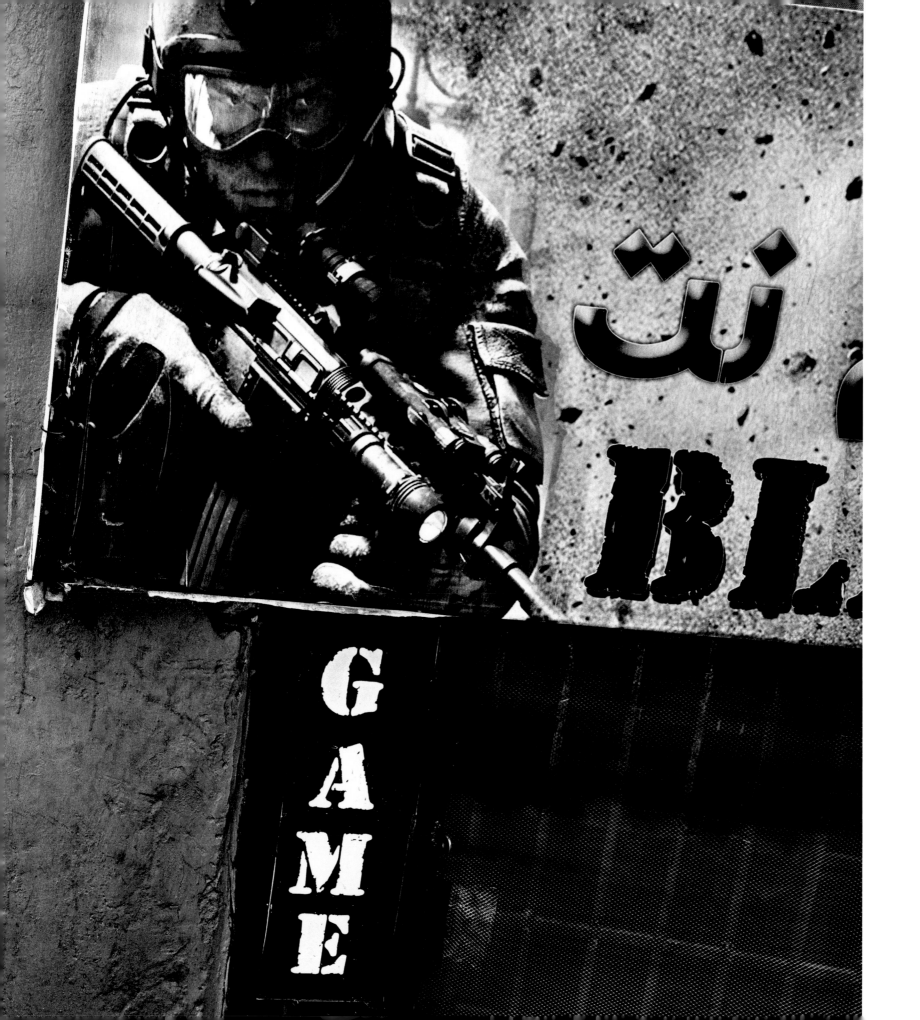

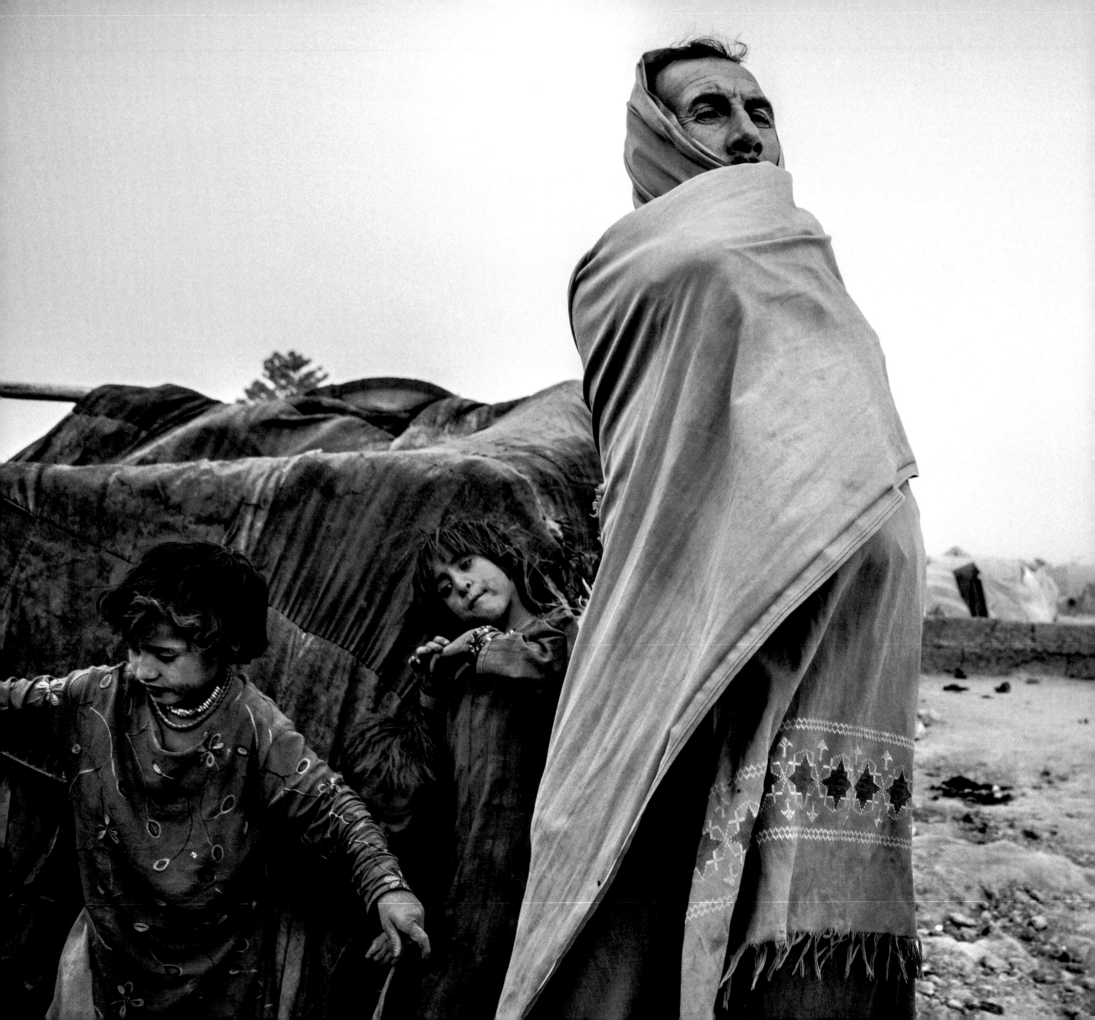

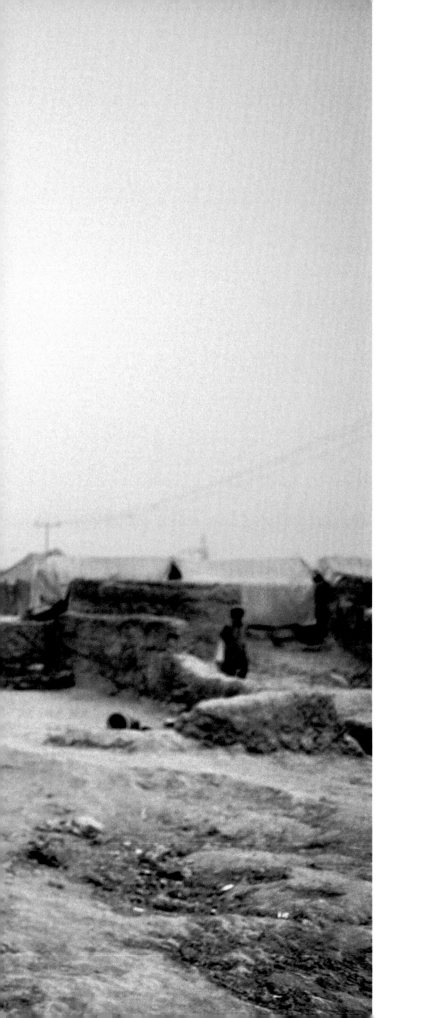

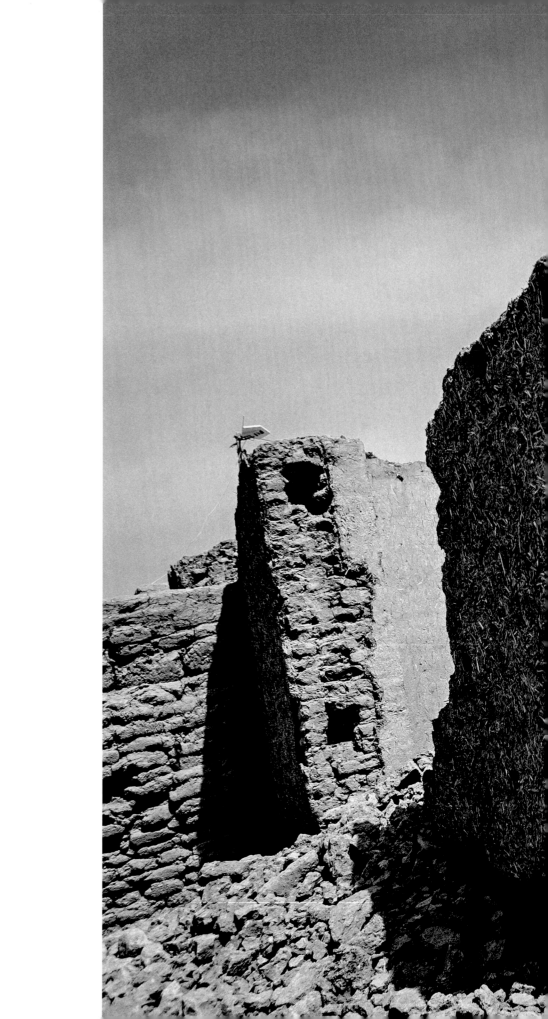

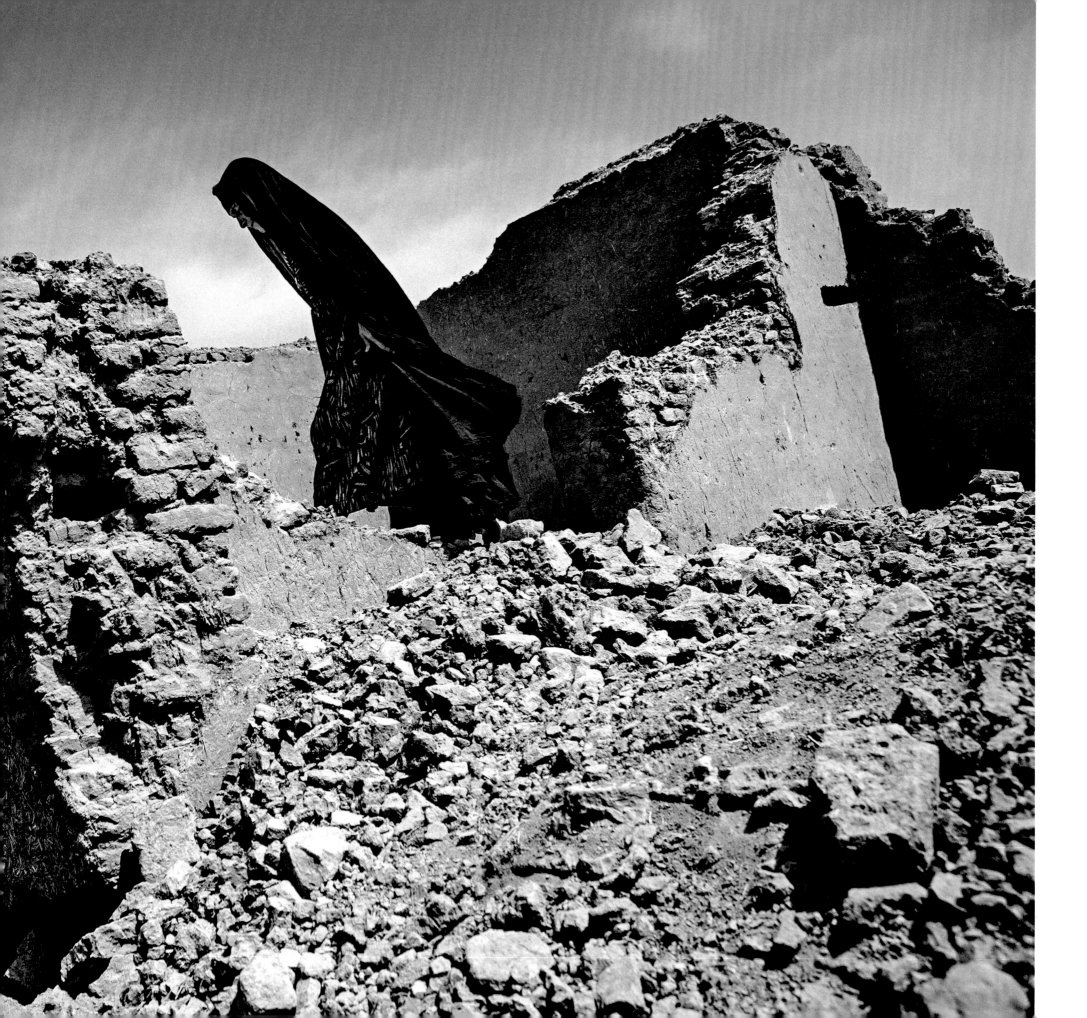

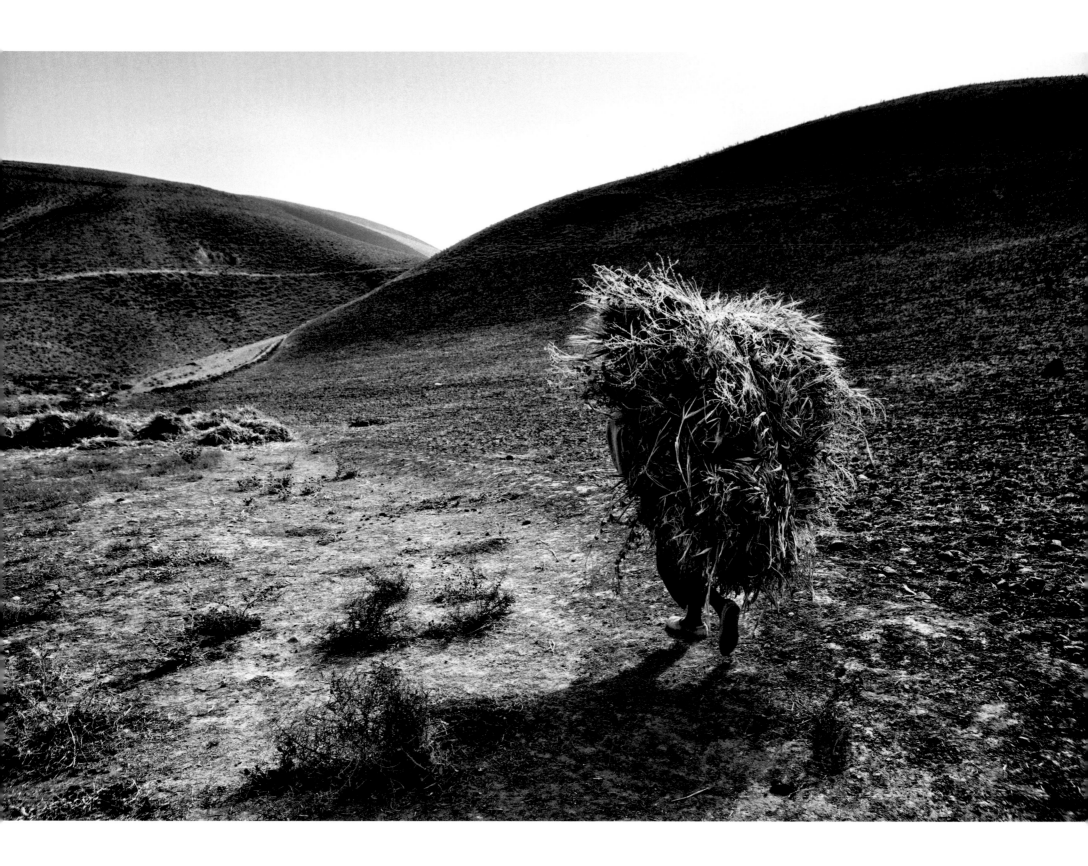

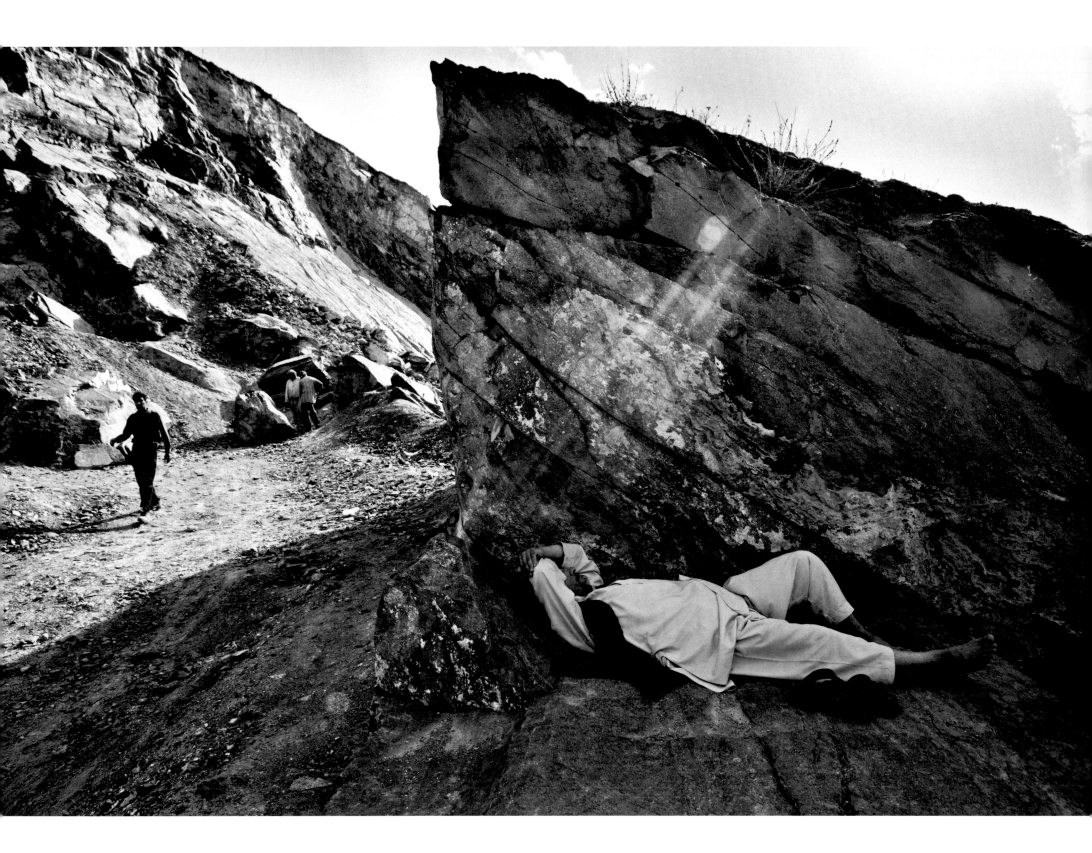

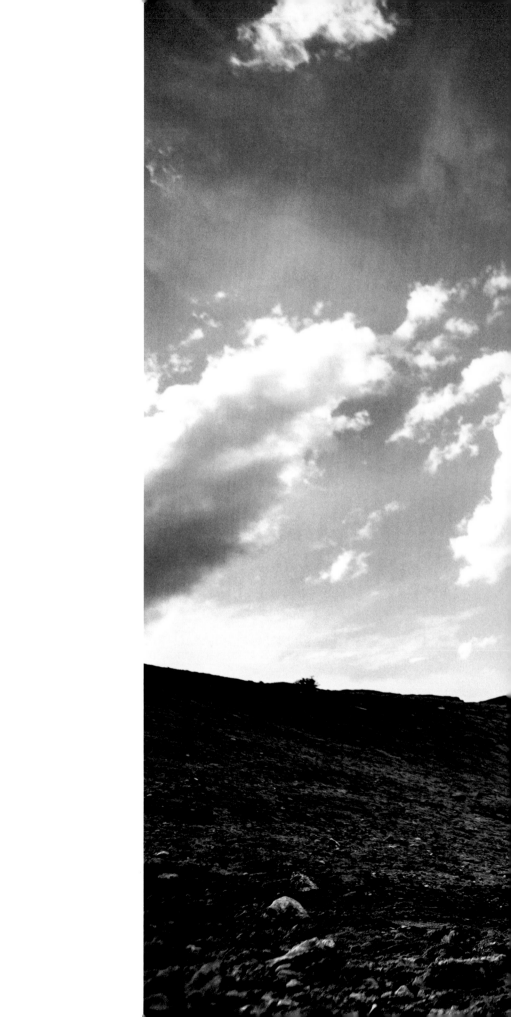

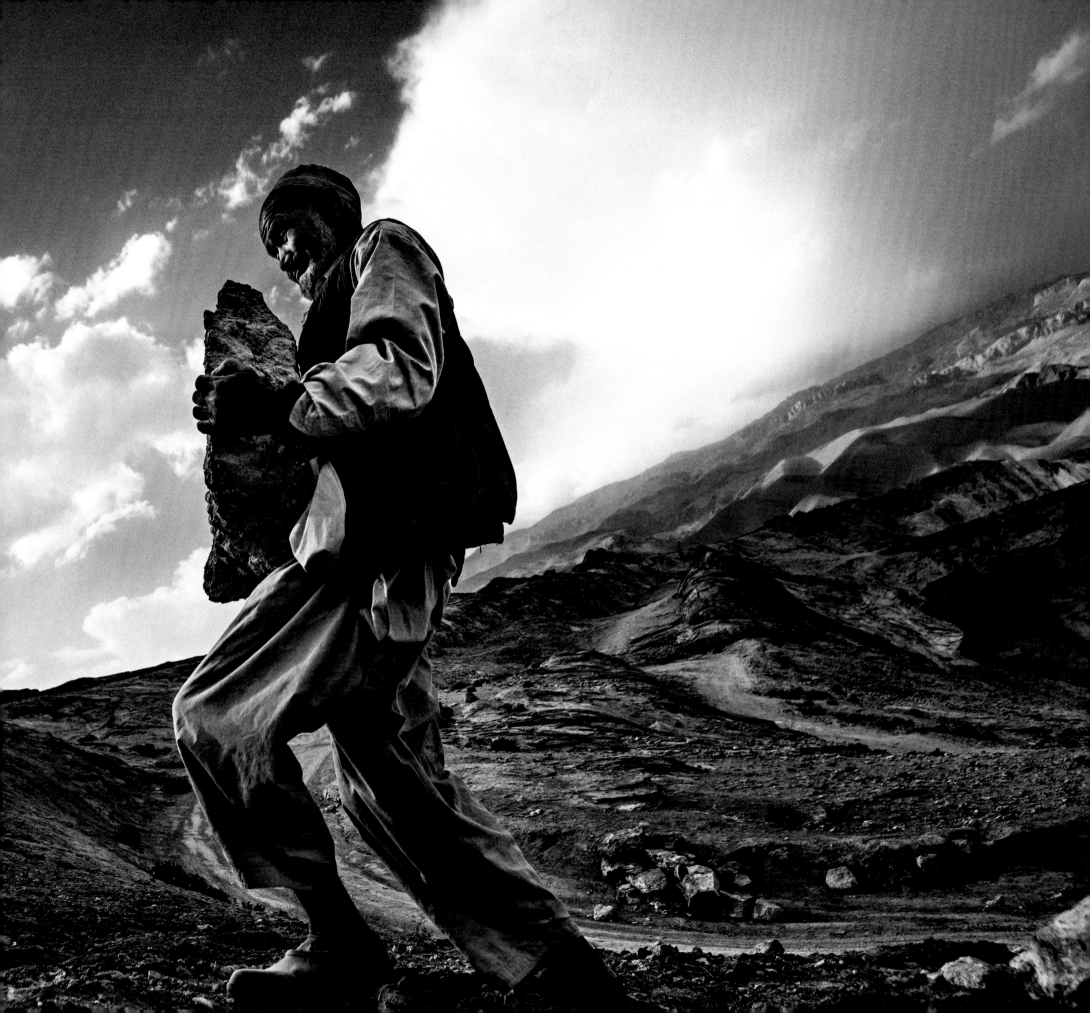

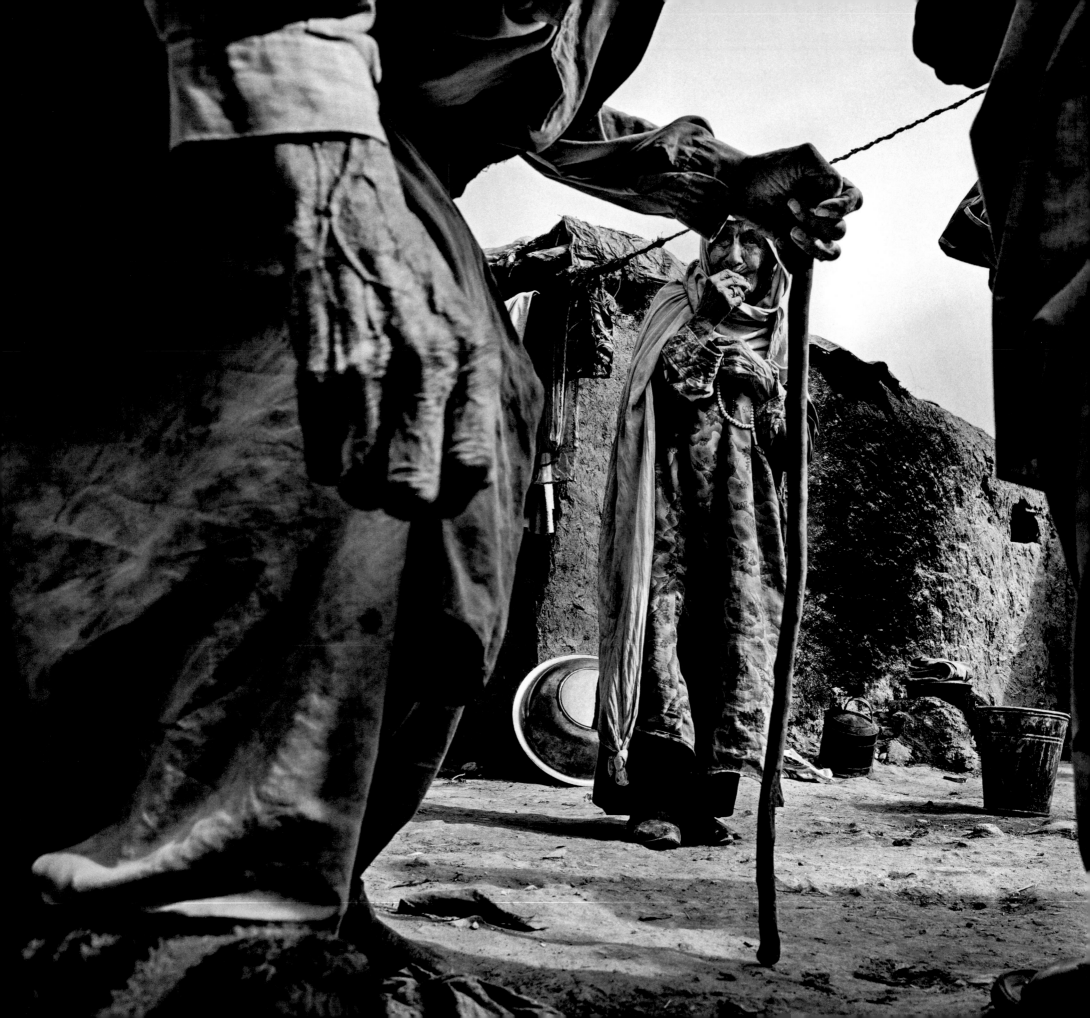

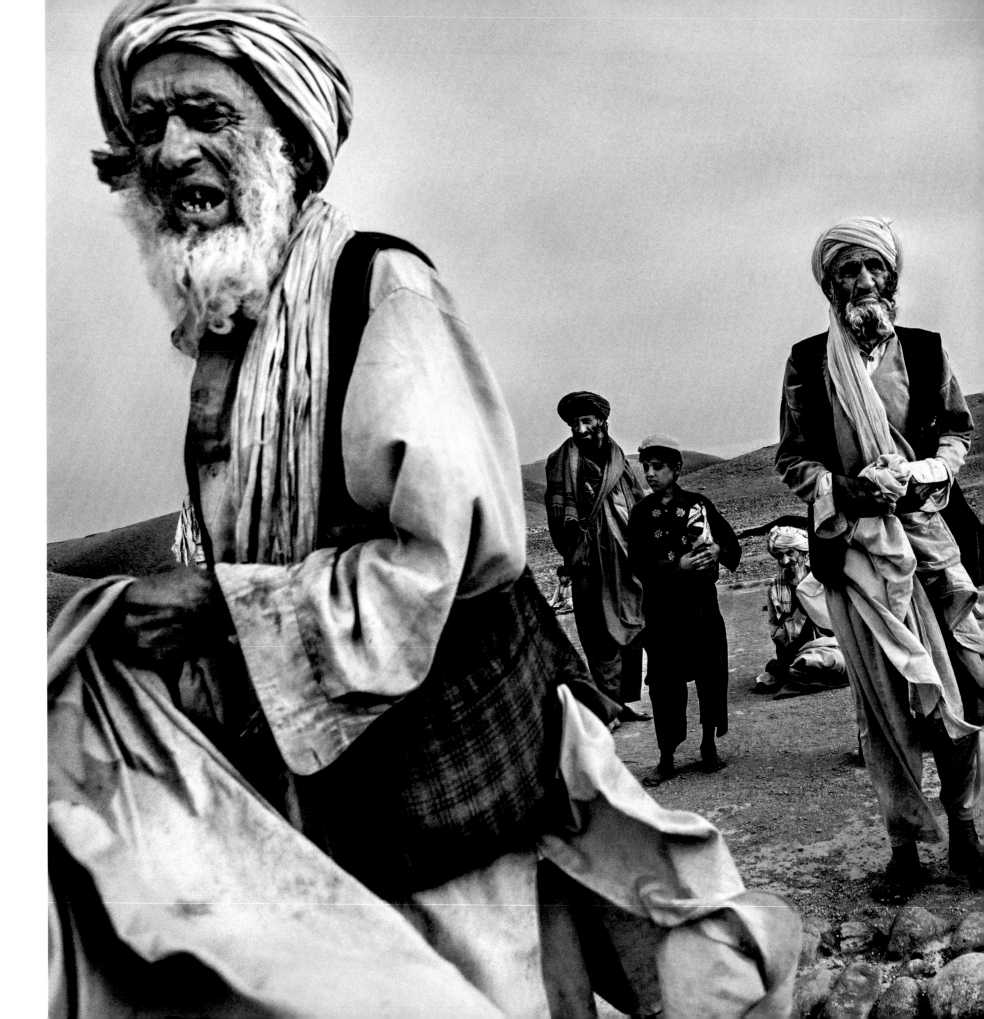

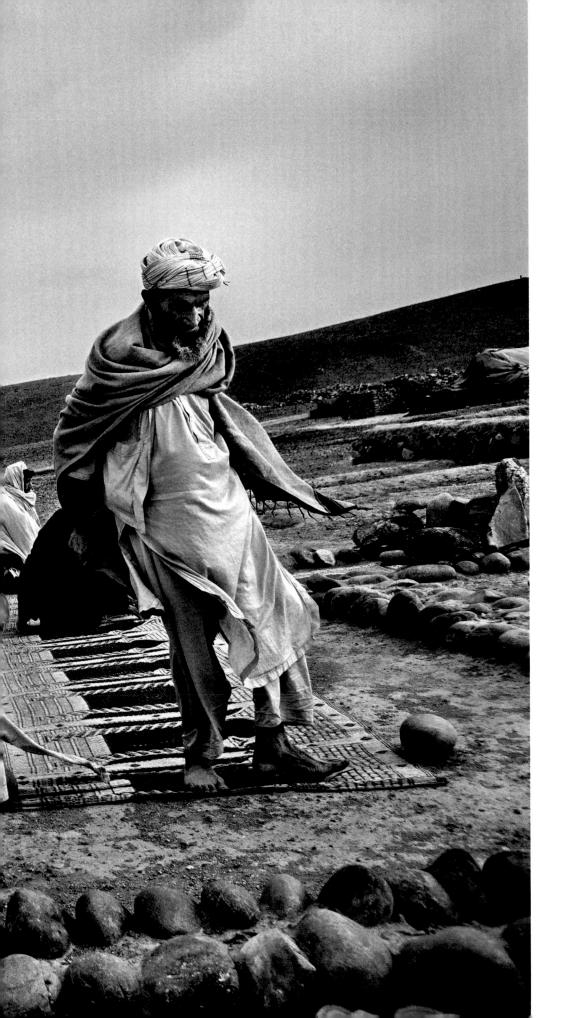

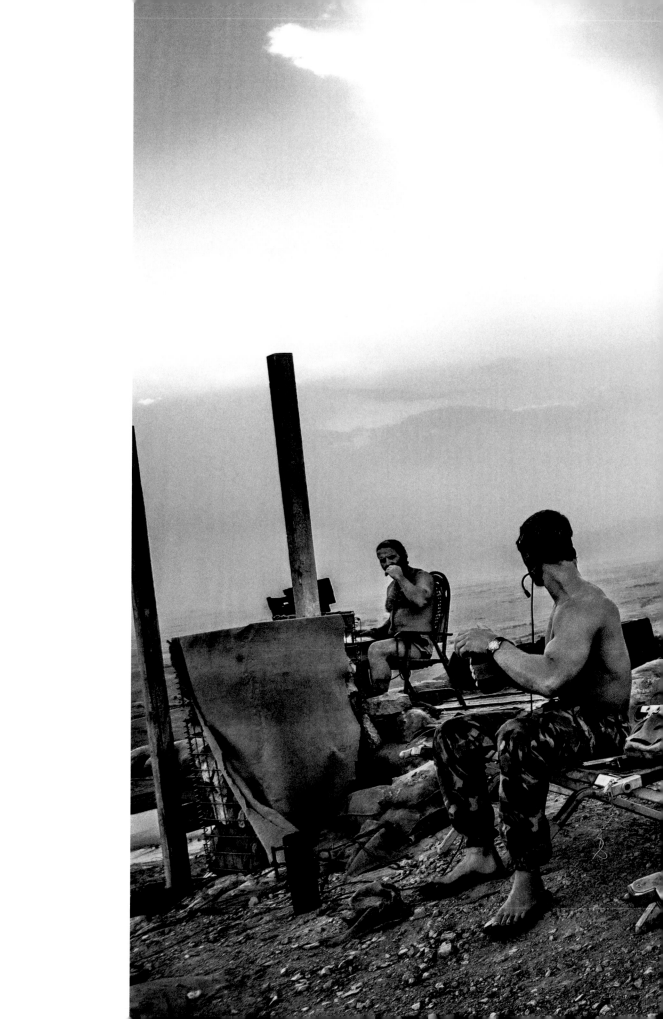

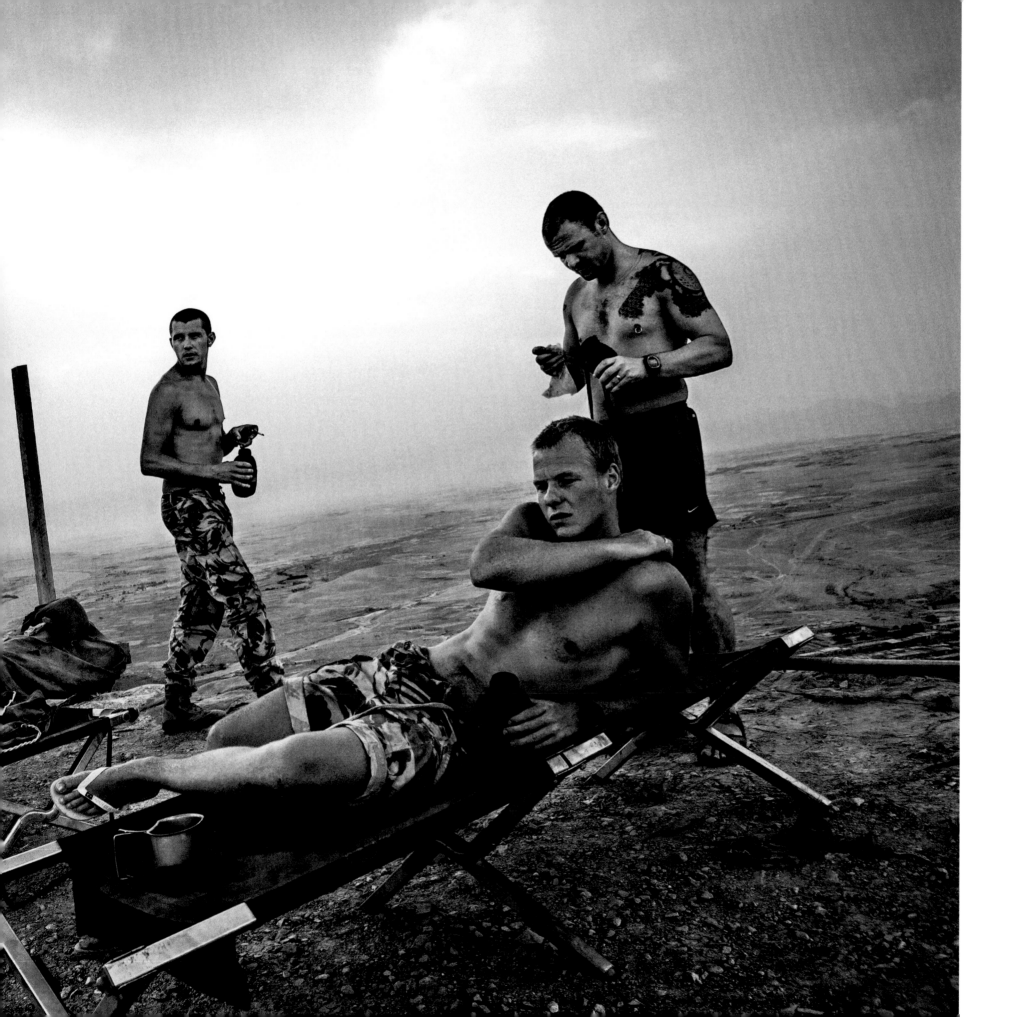

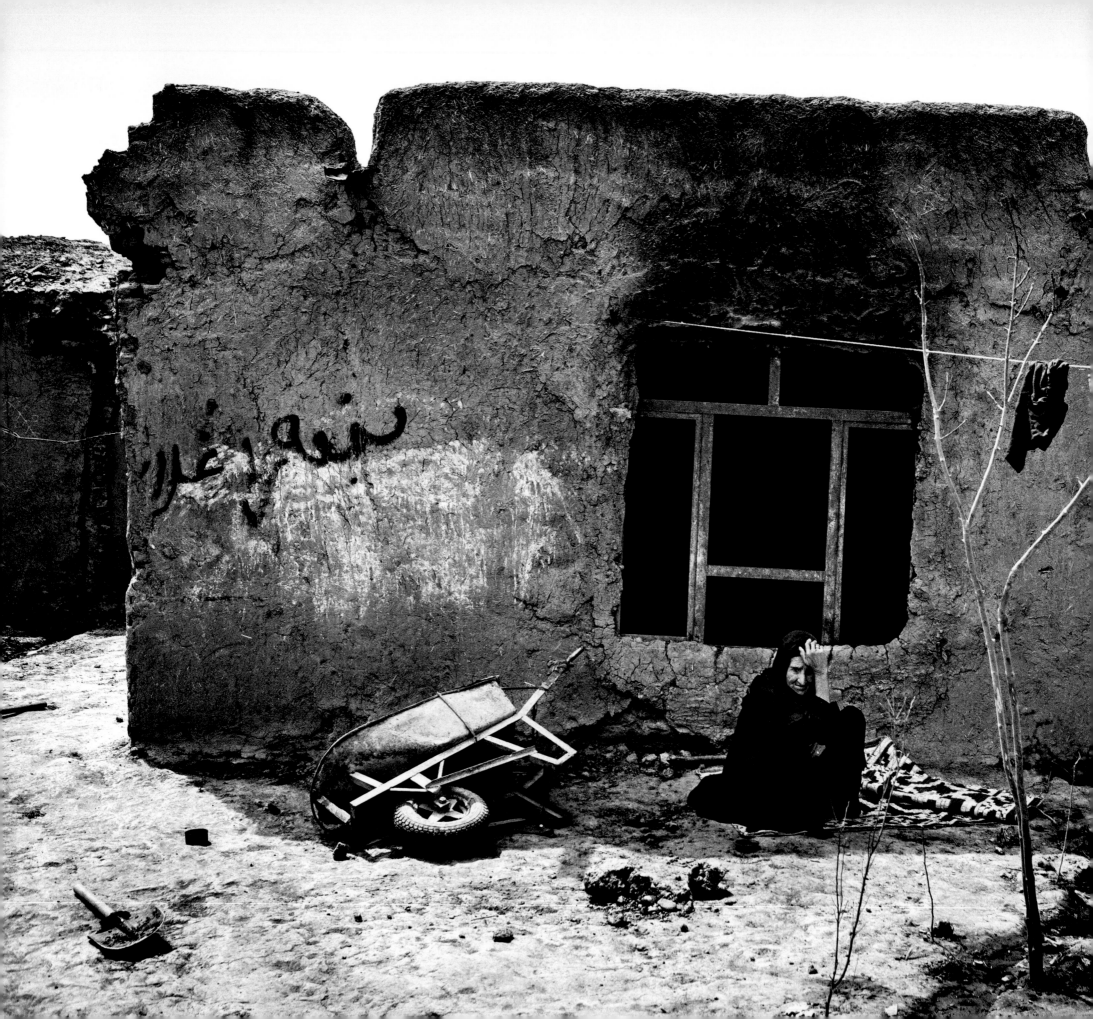

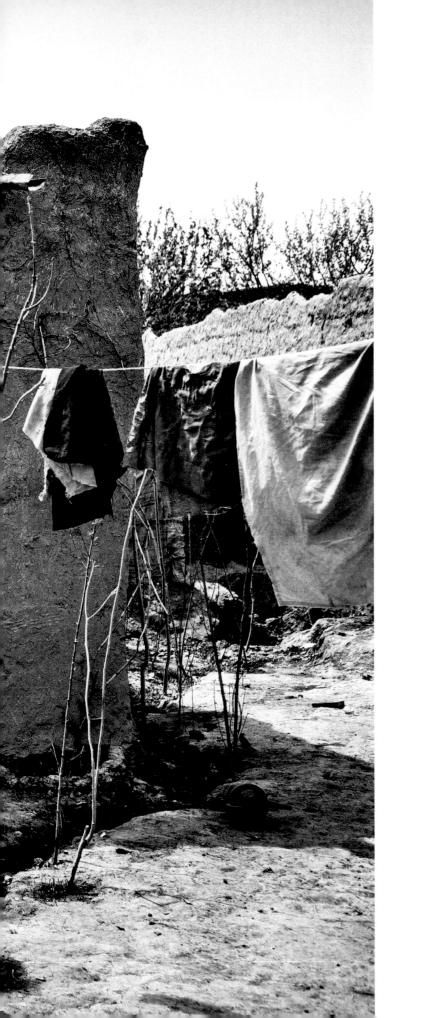

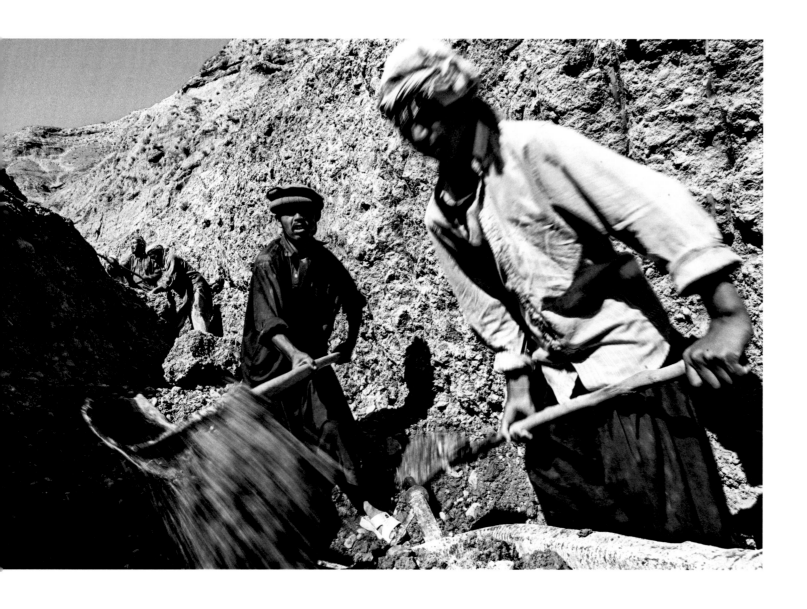

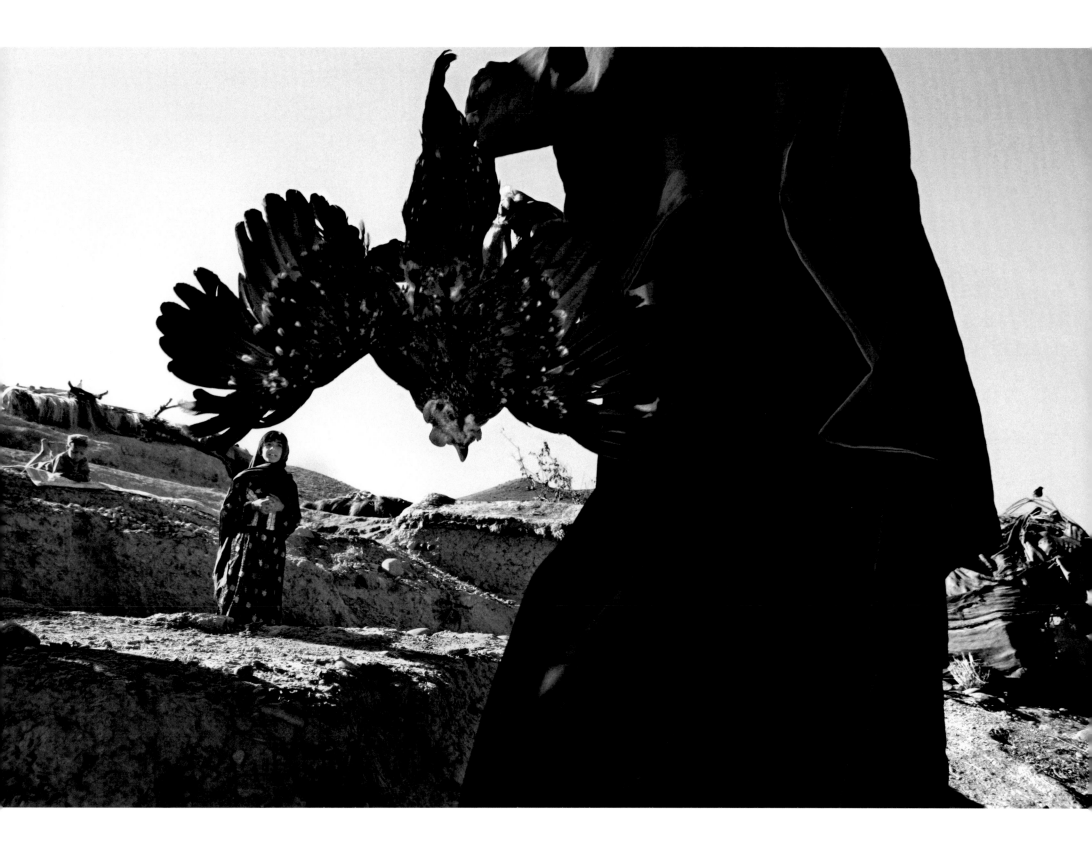

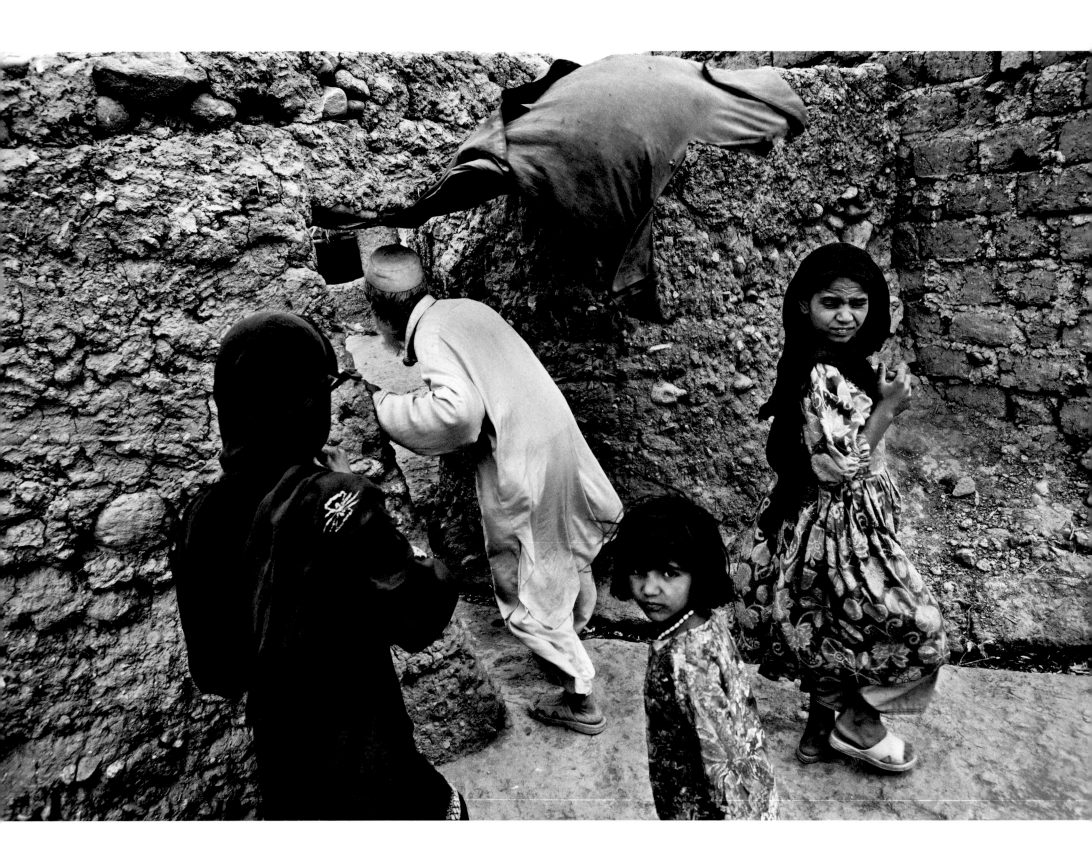

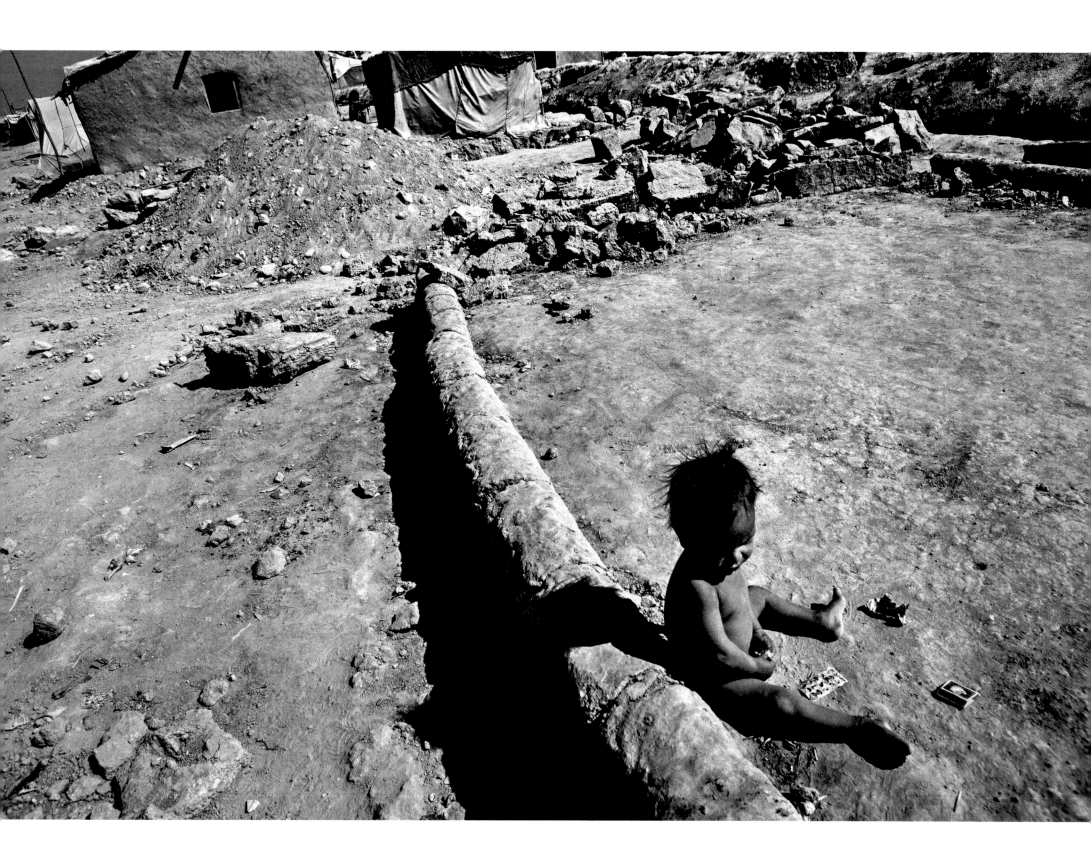

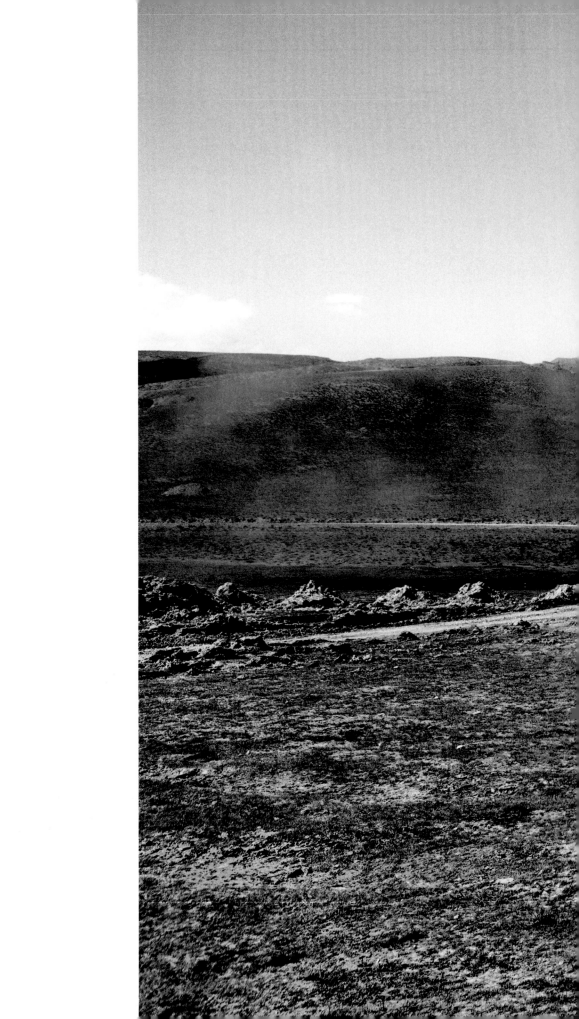

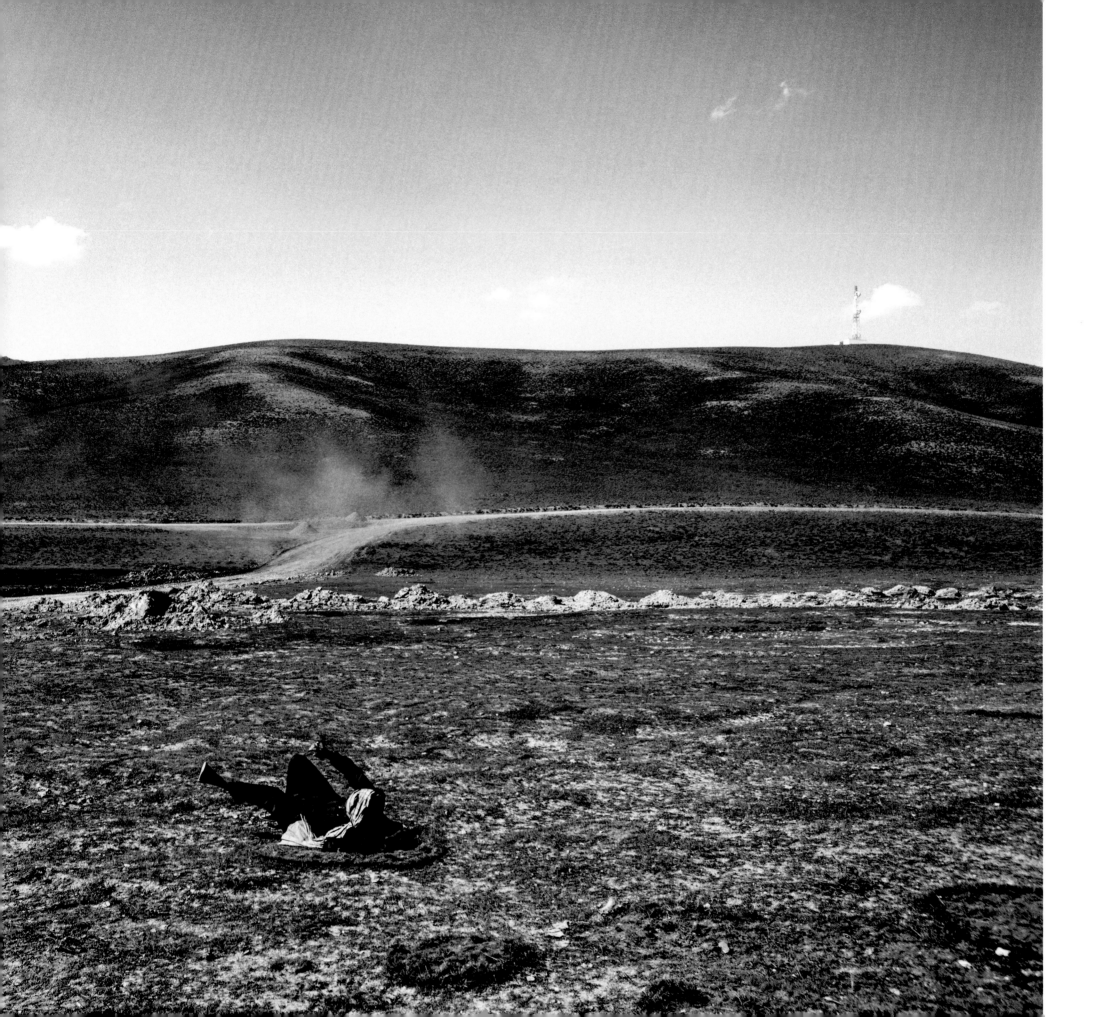

dream
/dr-ēm/

to contemplate the possibility of doing something
or that something might be the case.

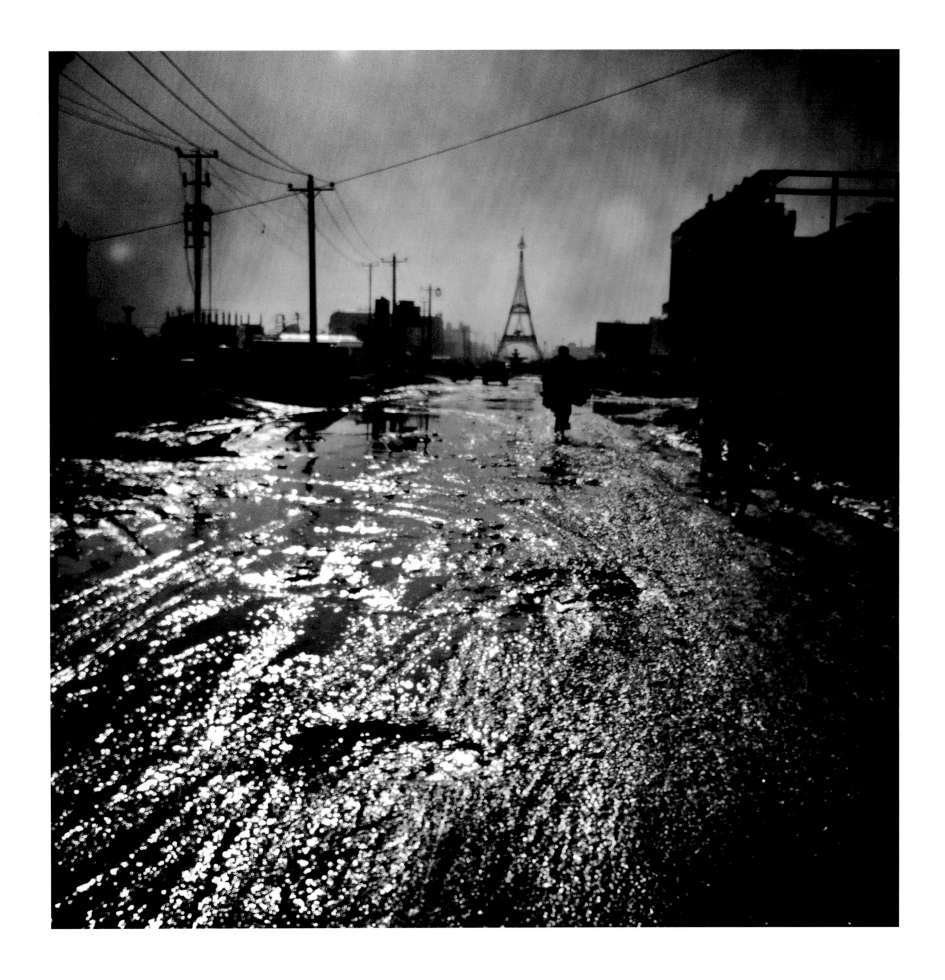

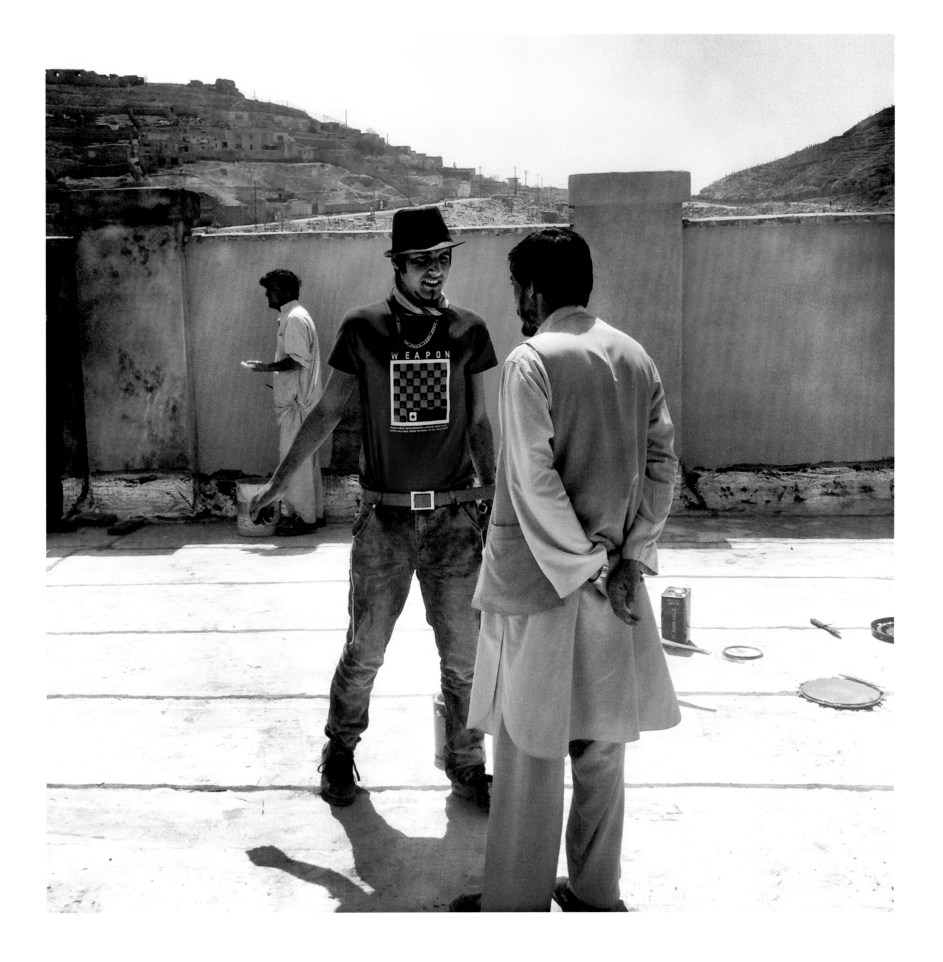

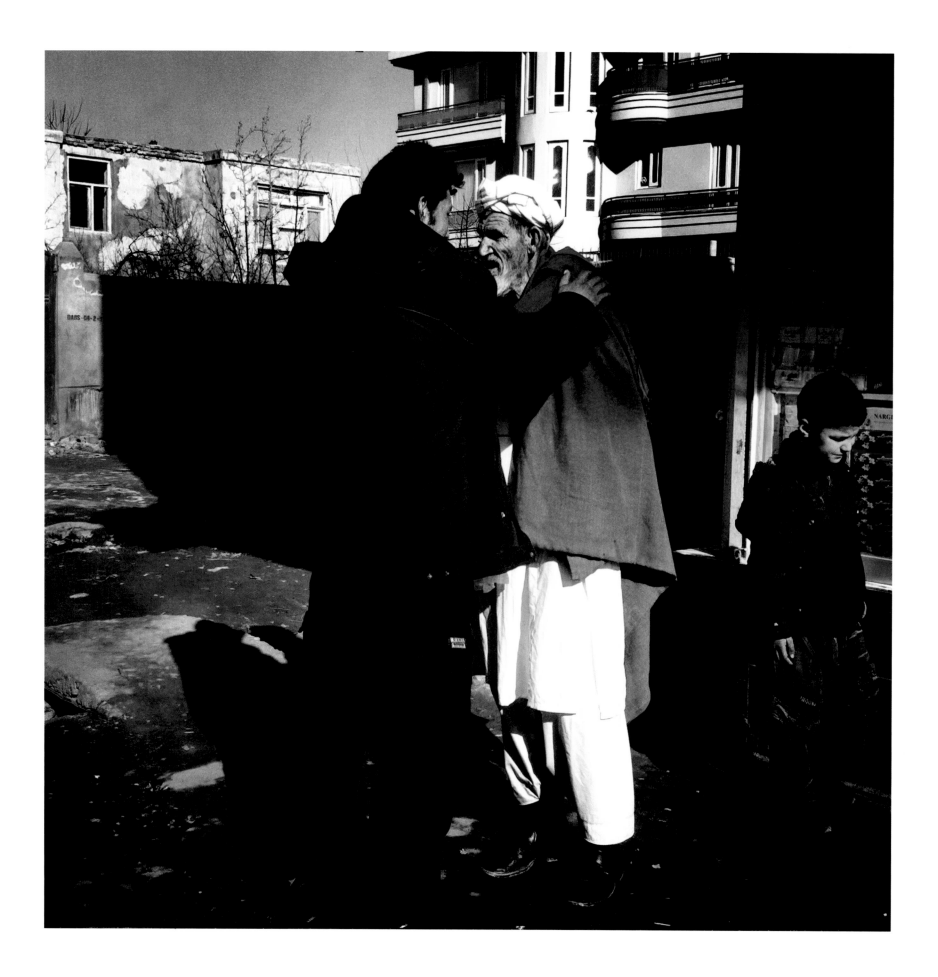

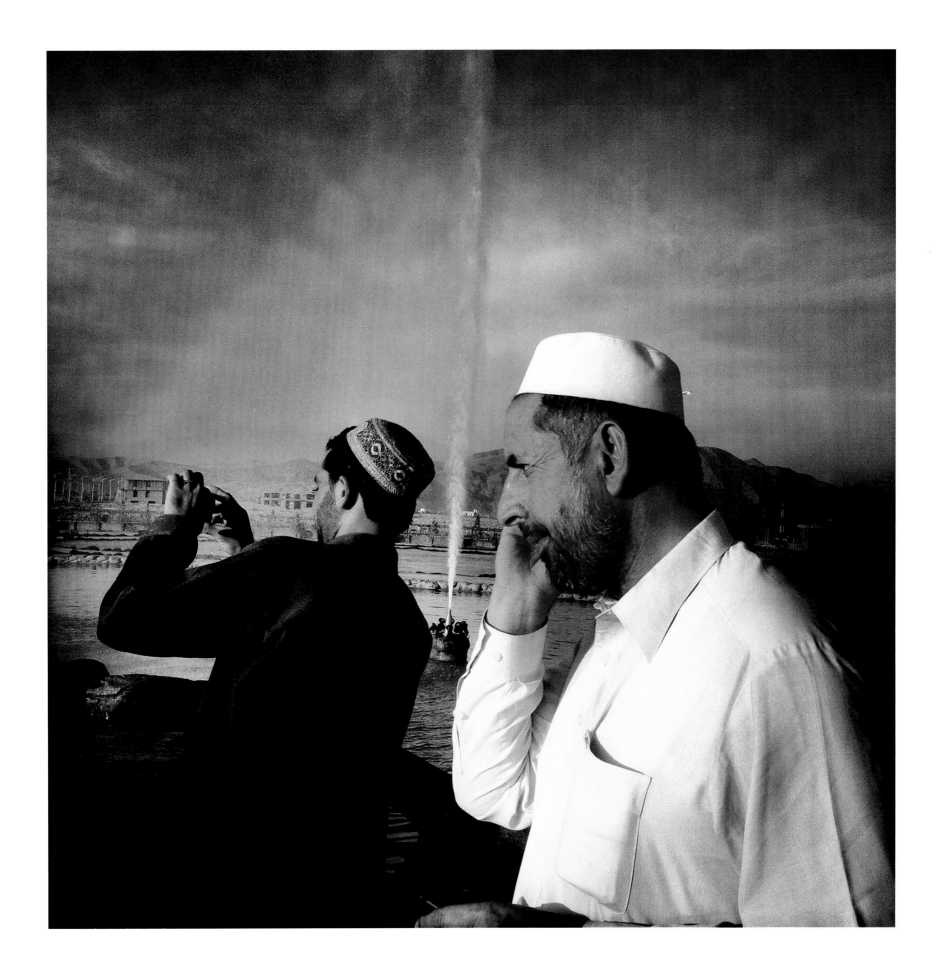

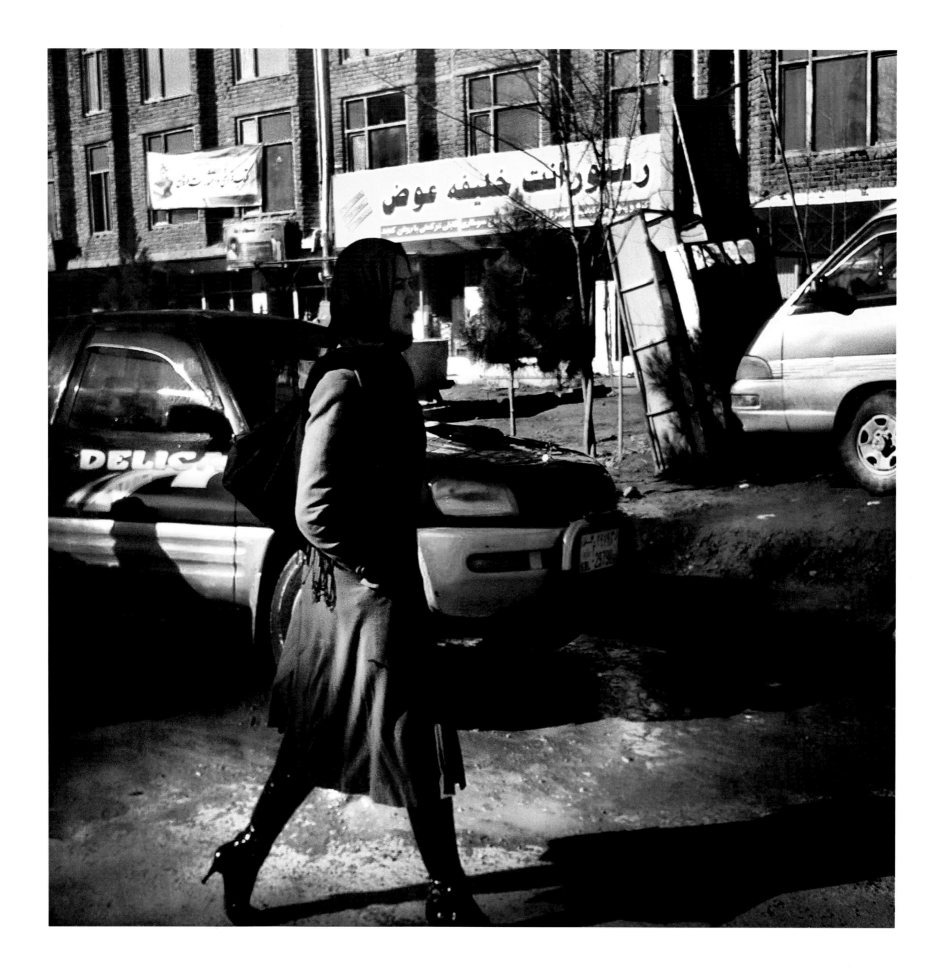

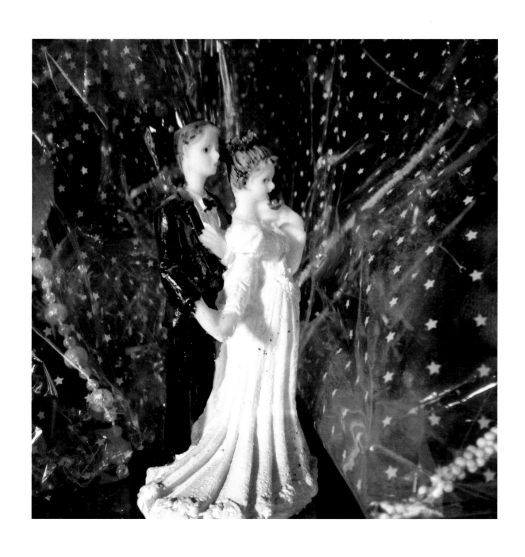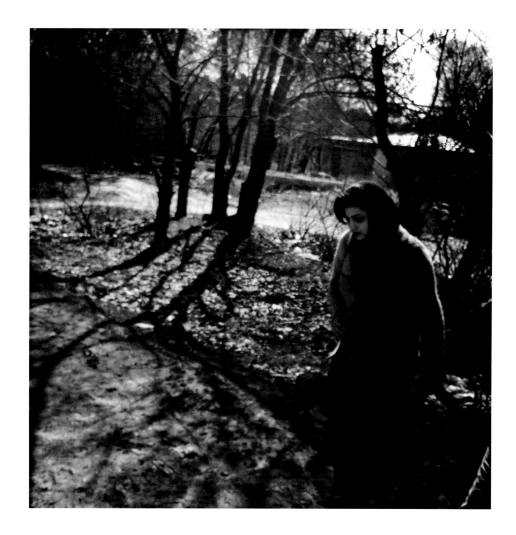

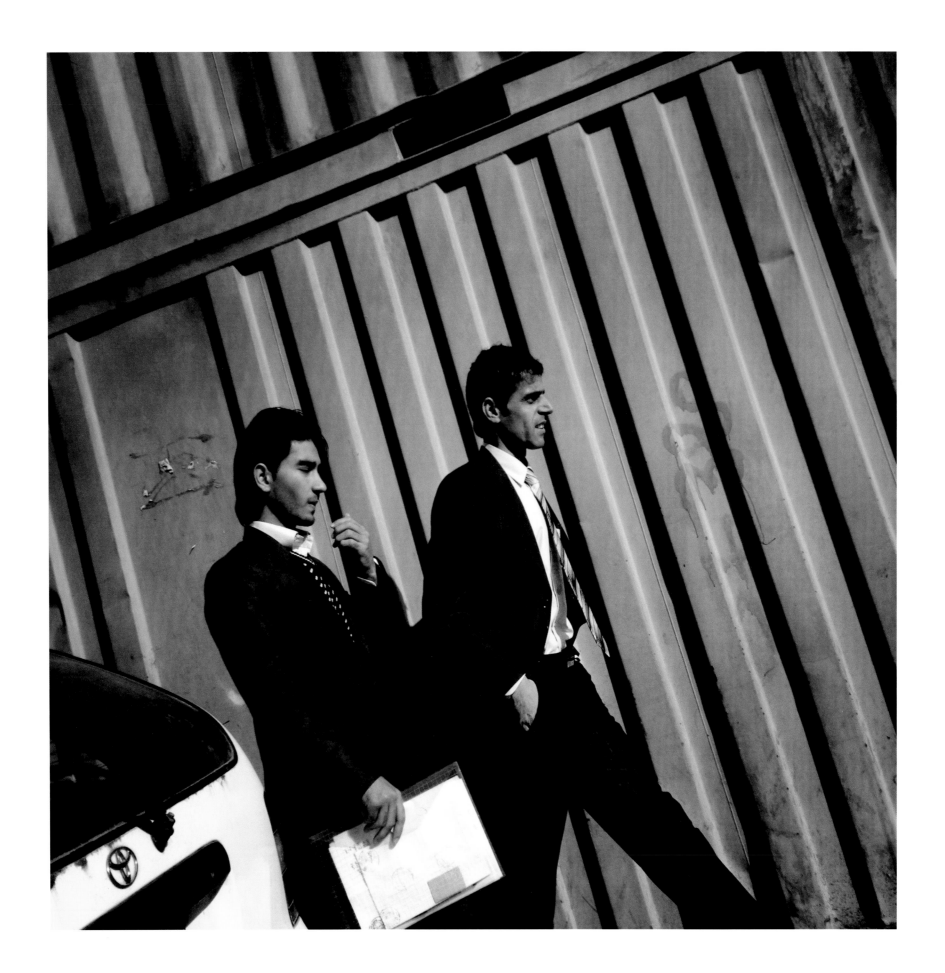

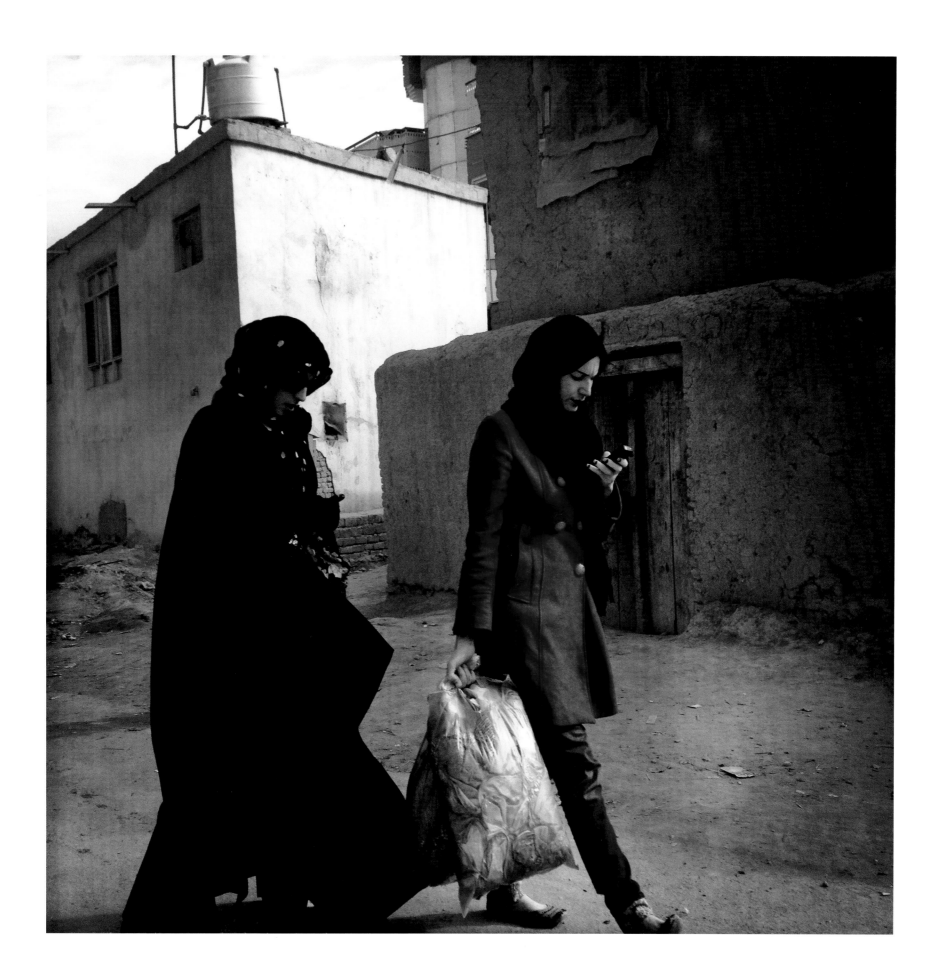

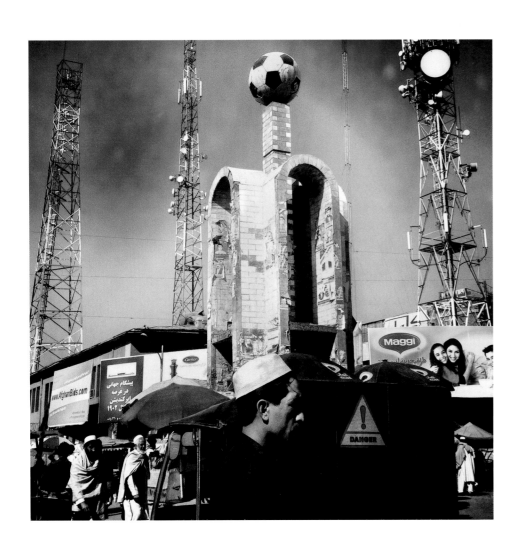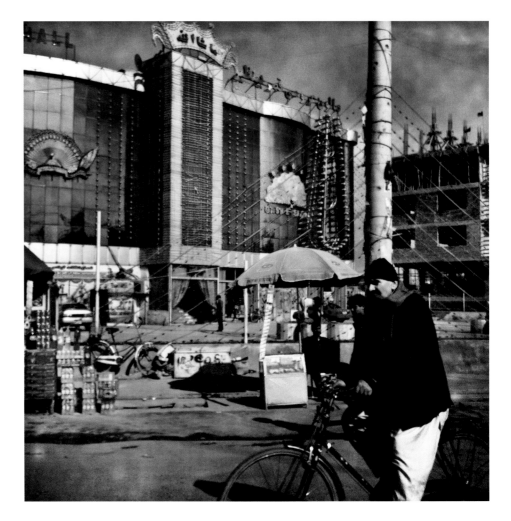

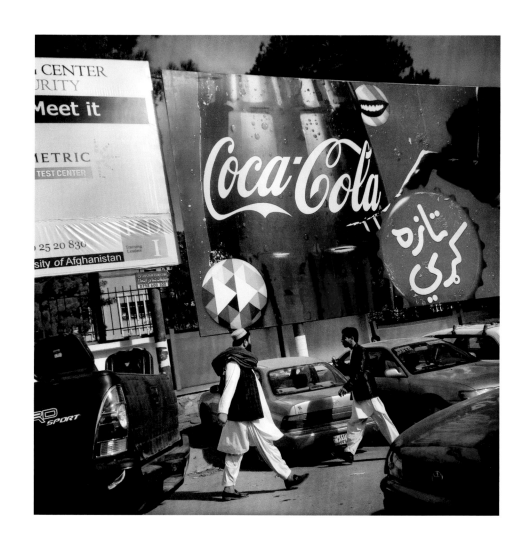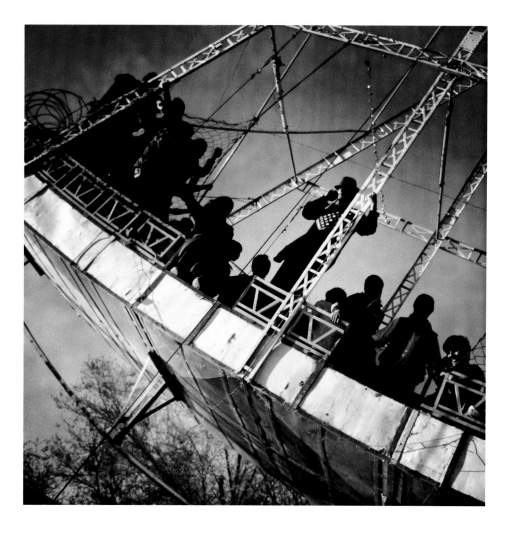

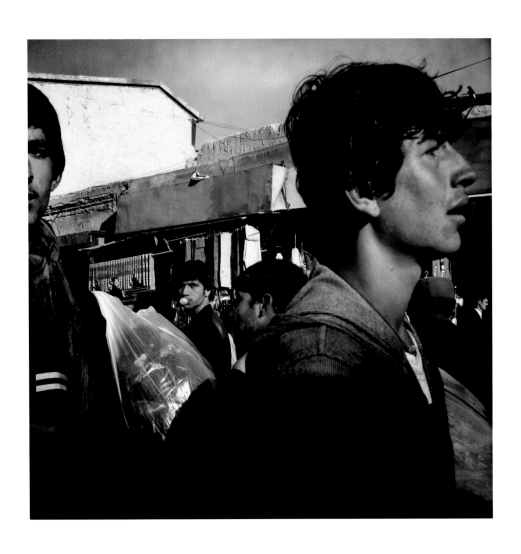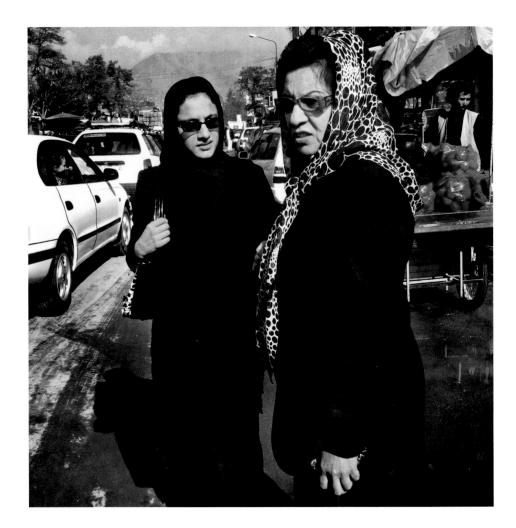

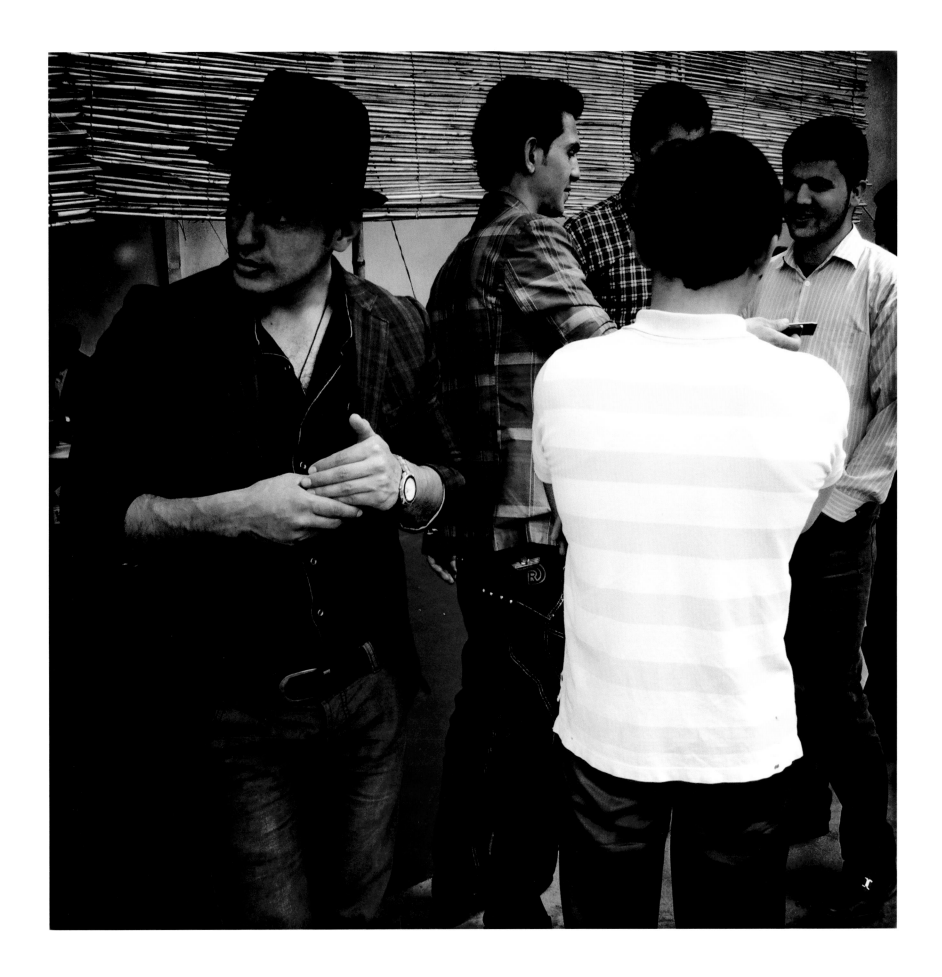

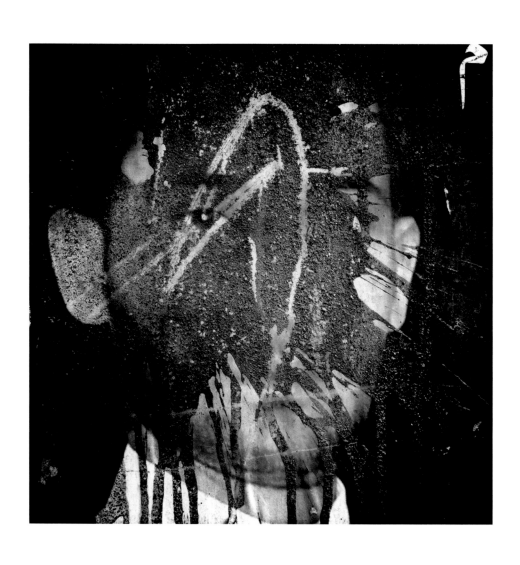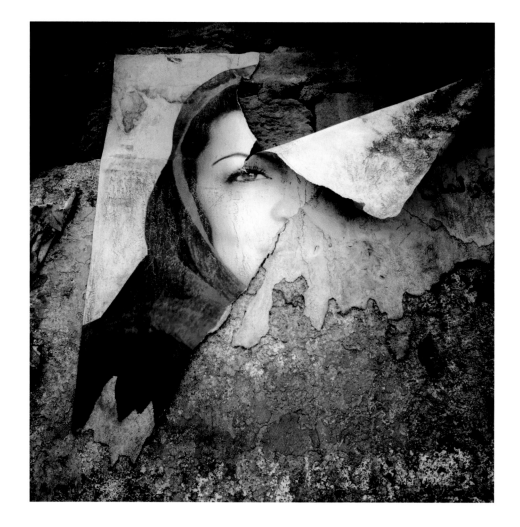

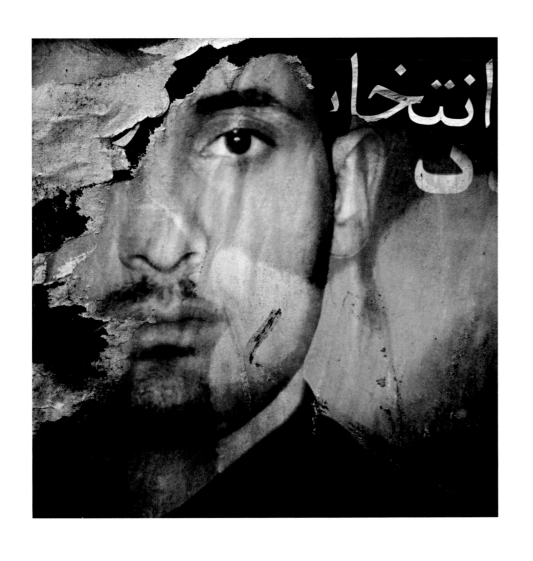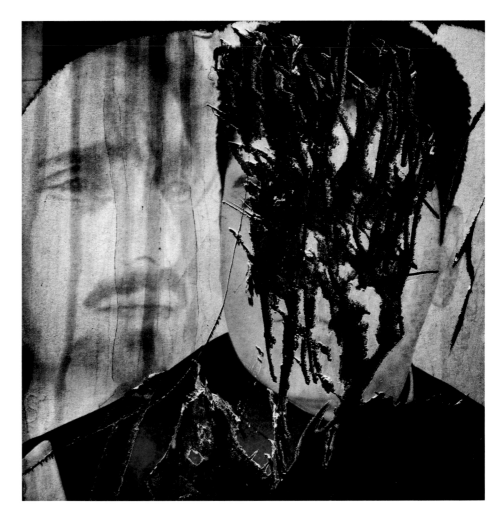

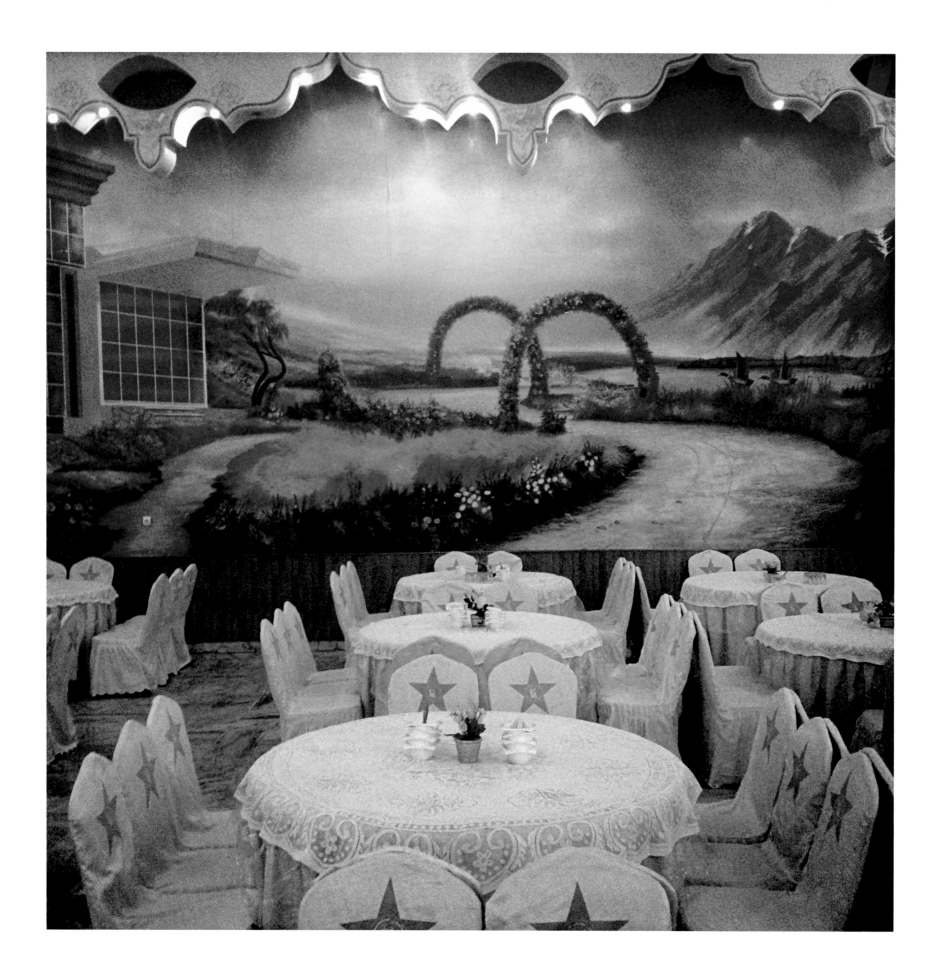

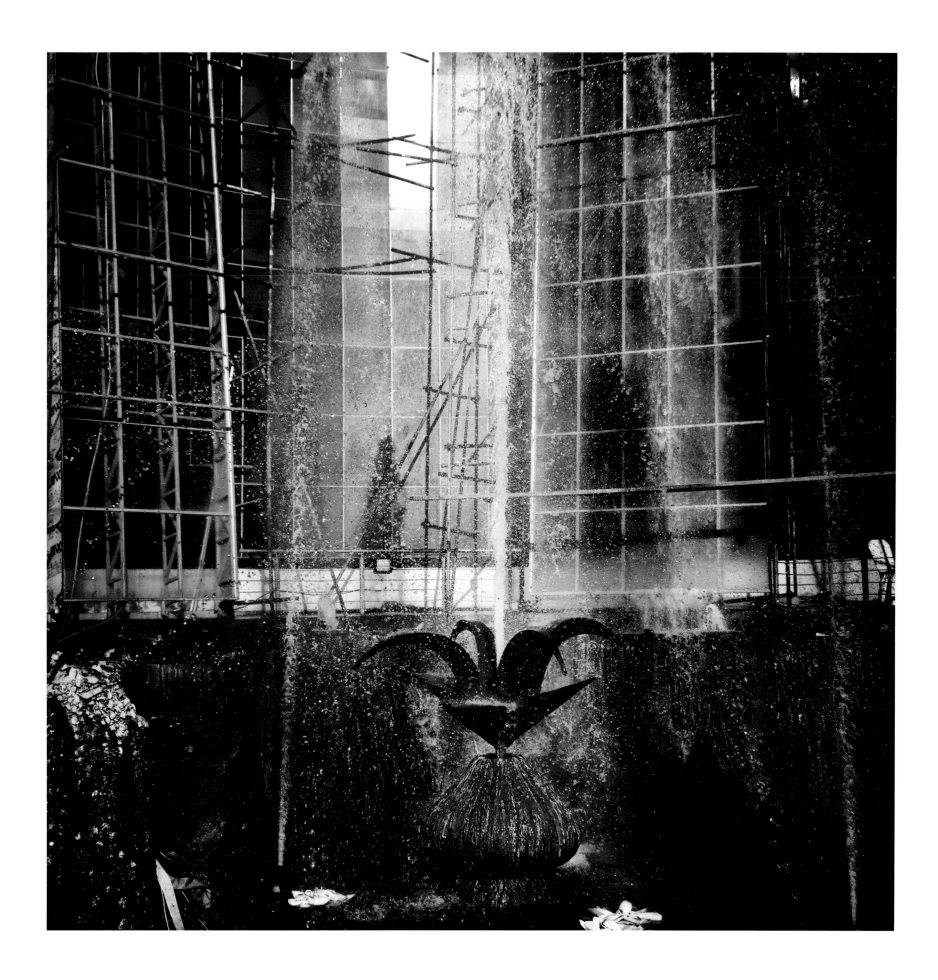

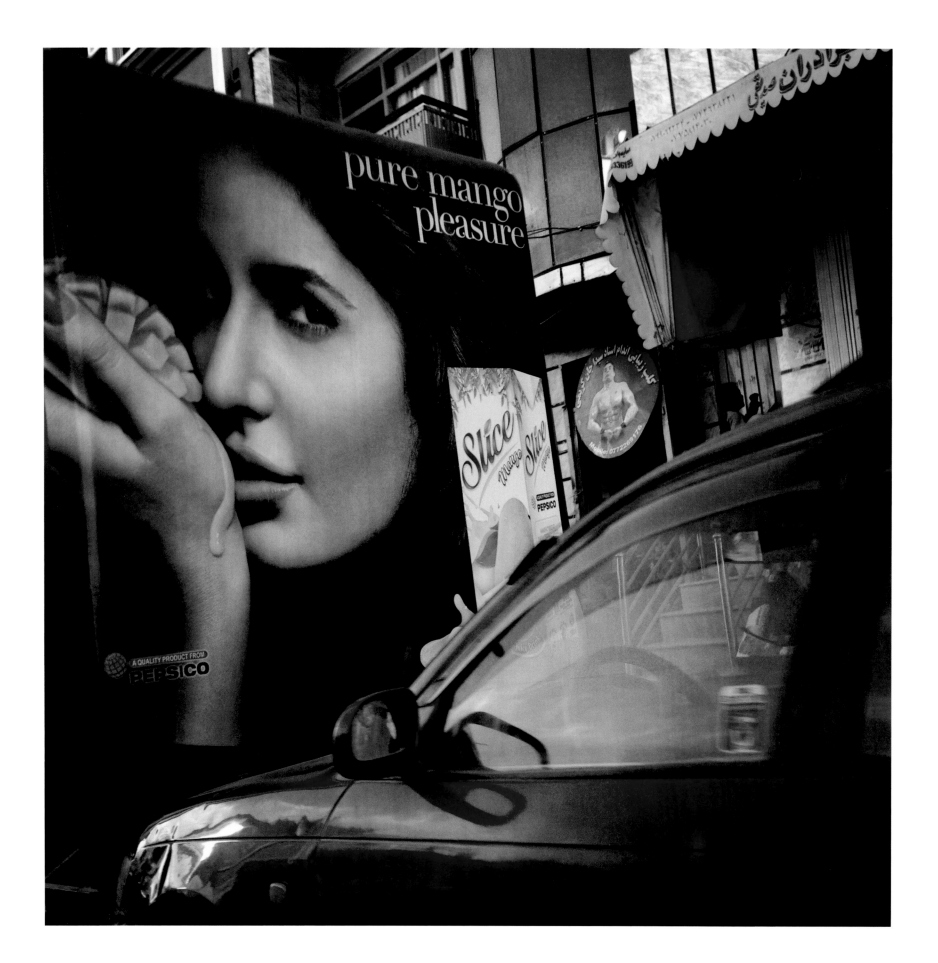

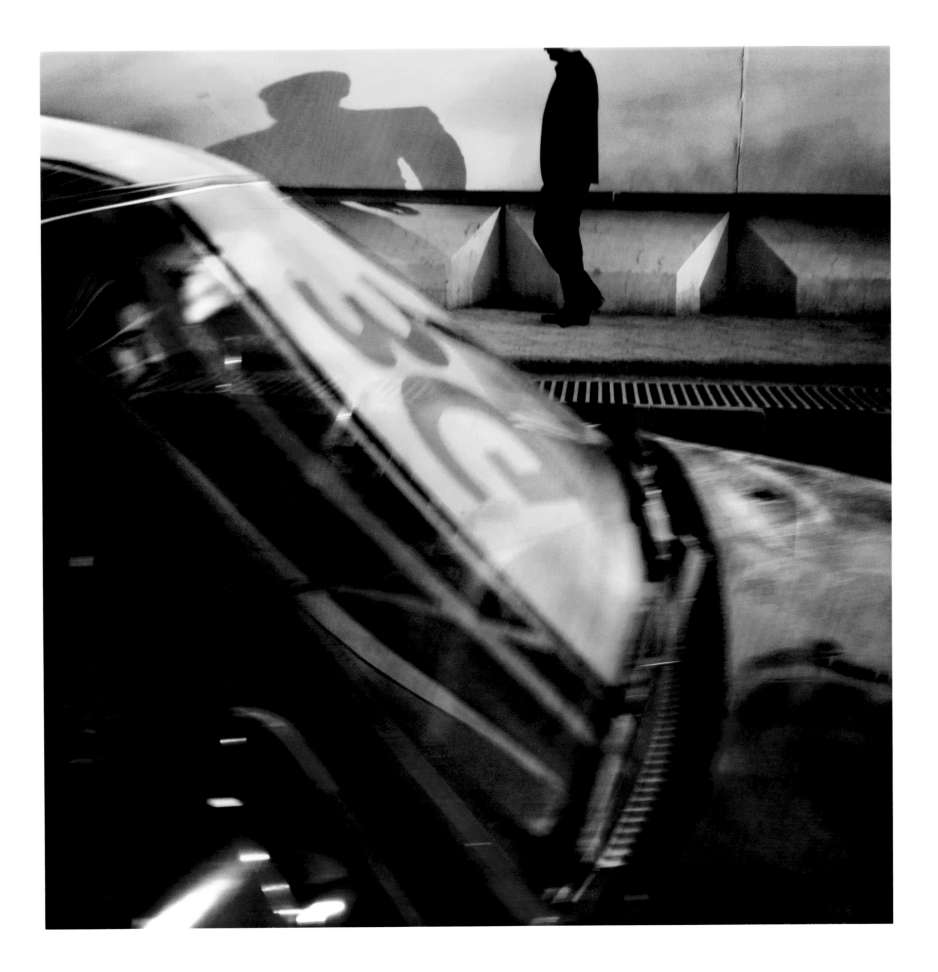

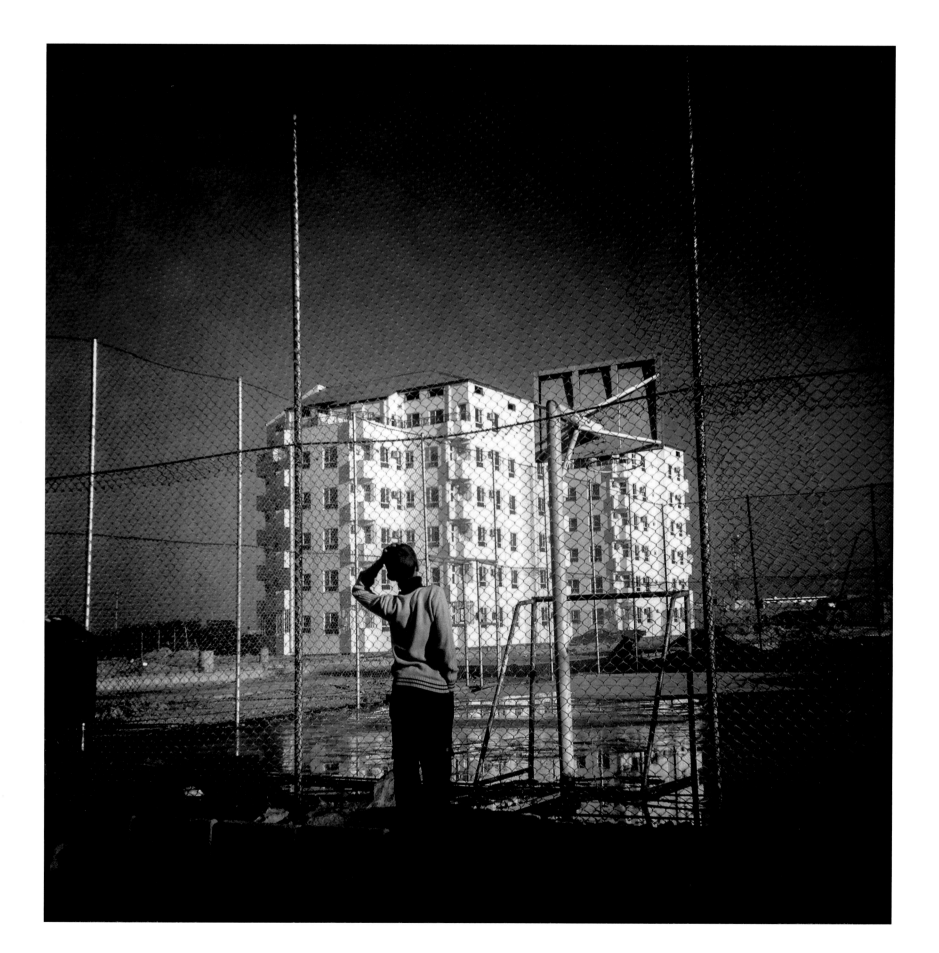

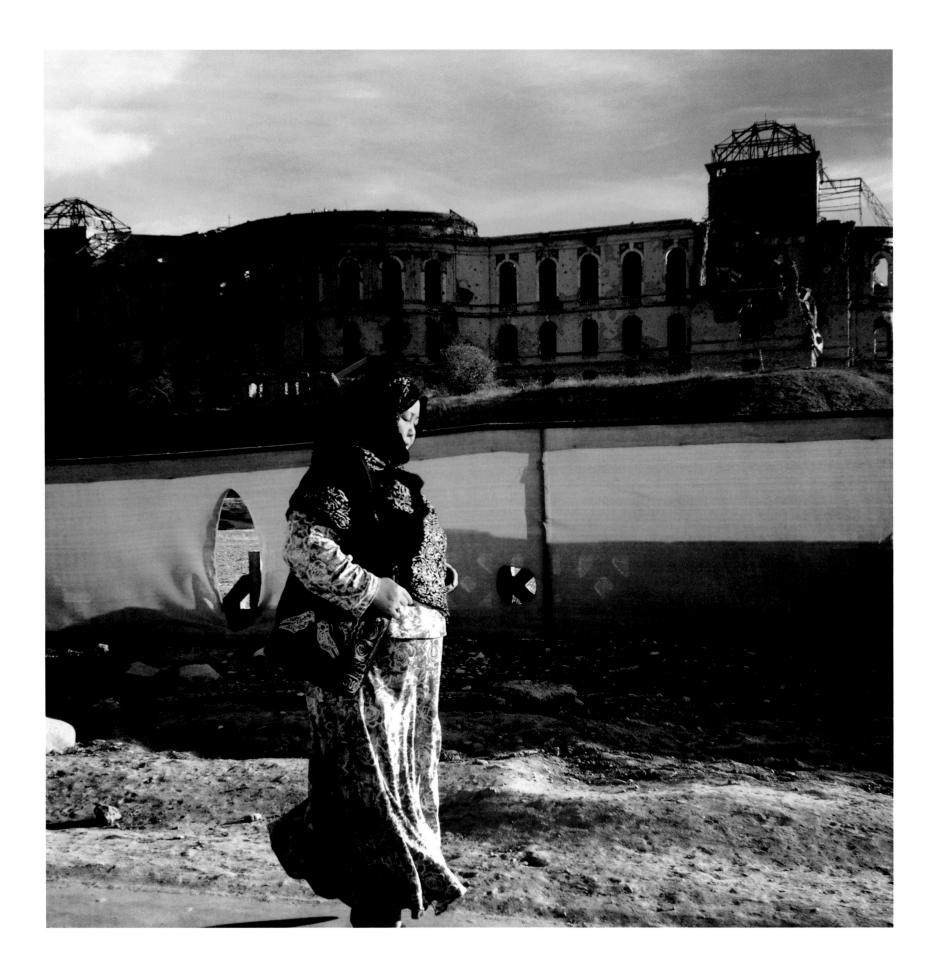

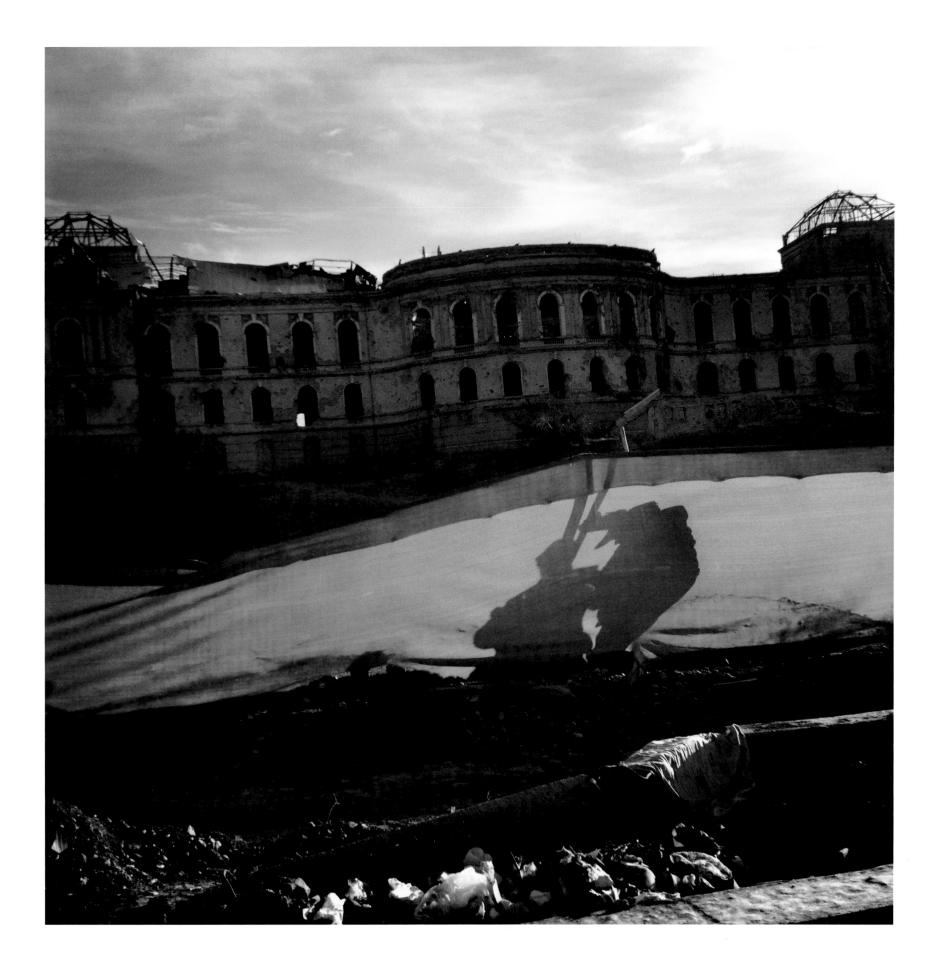

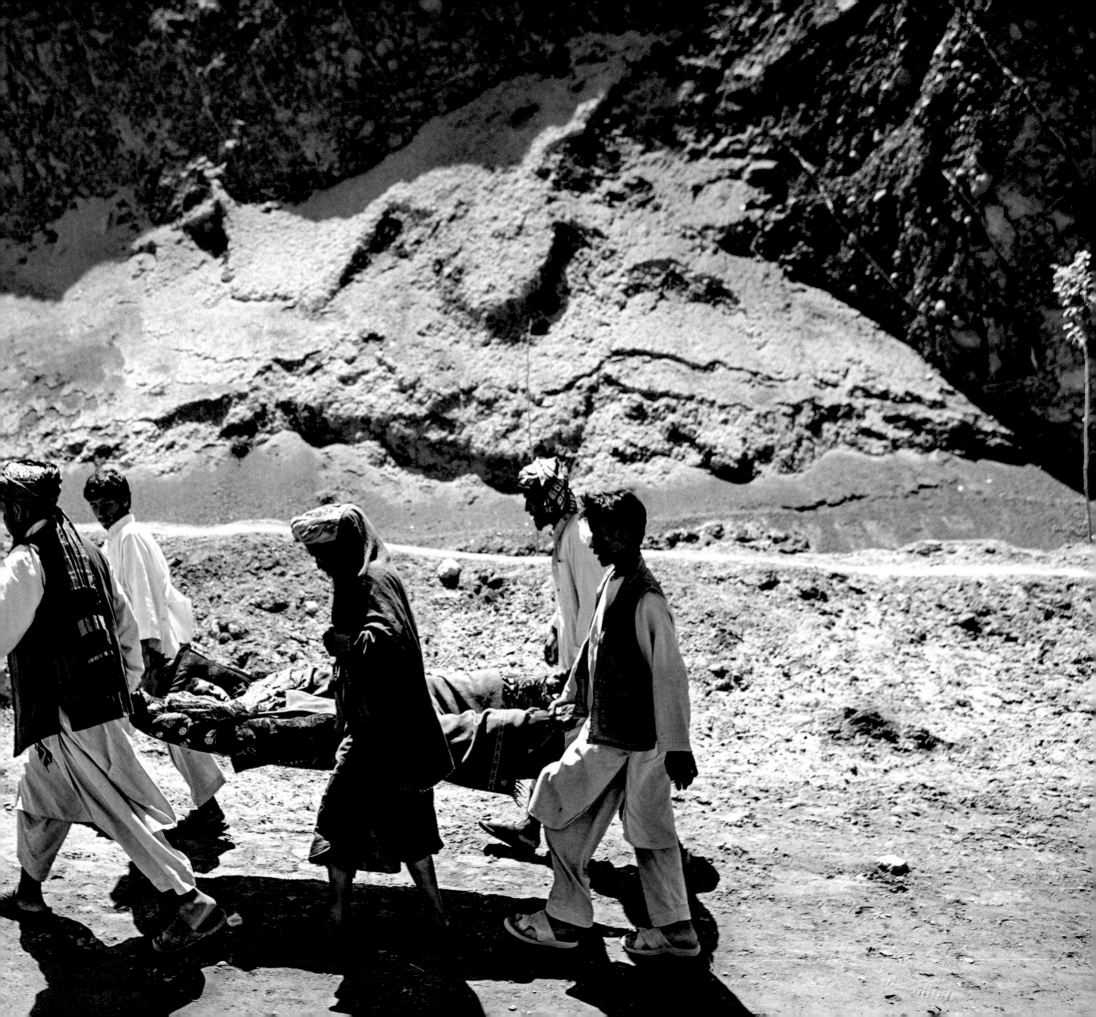

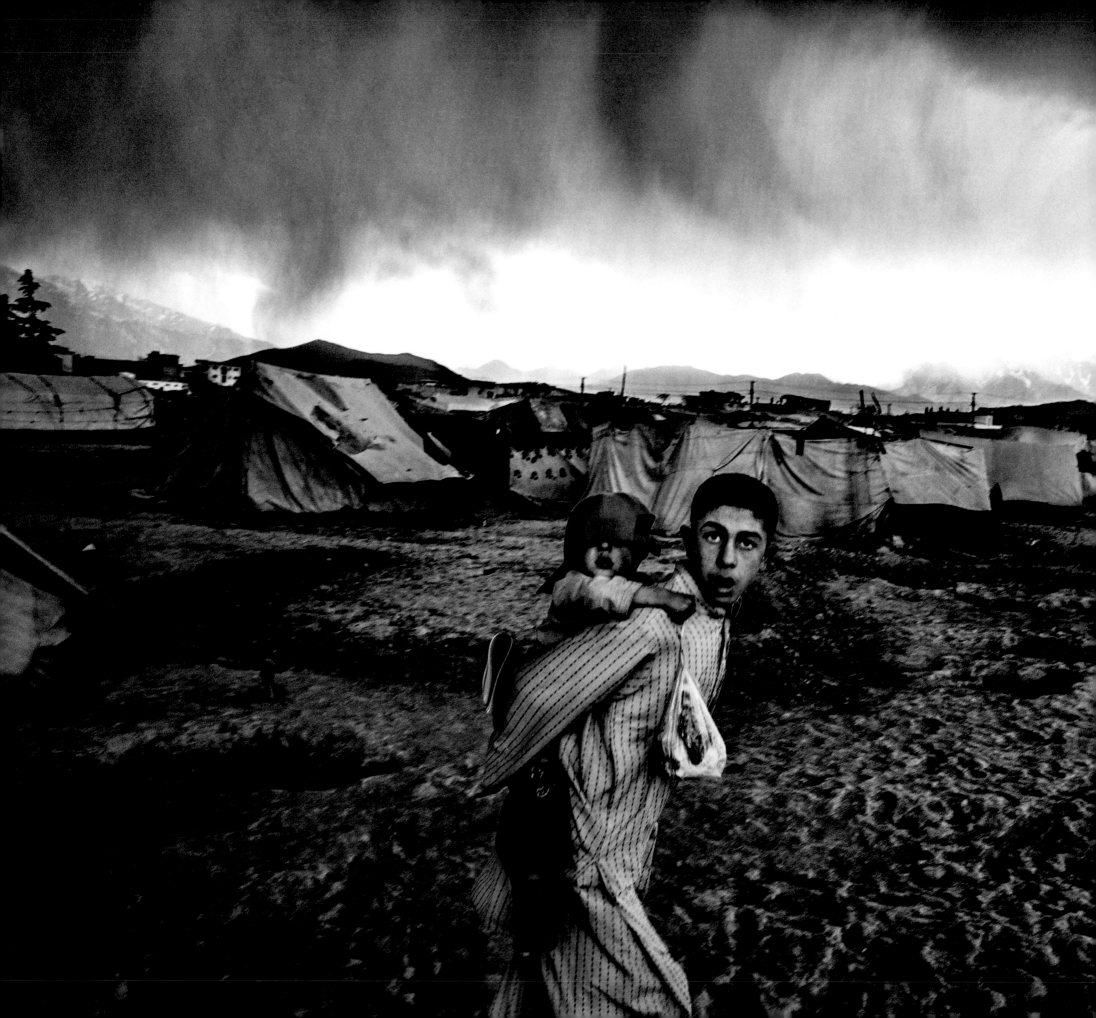

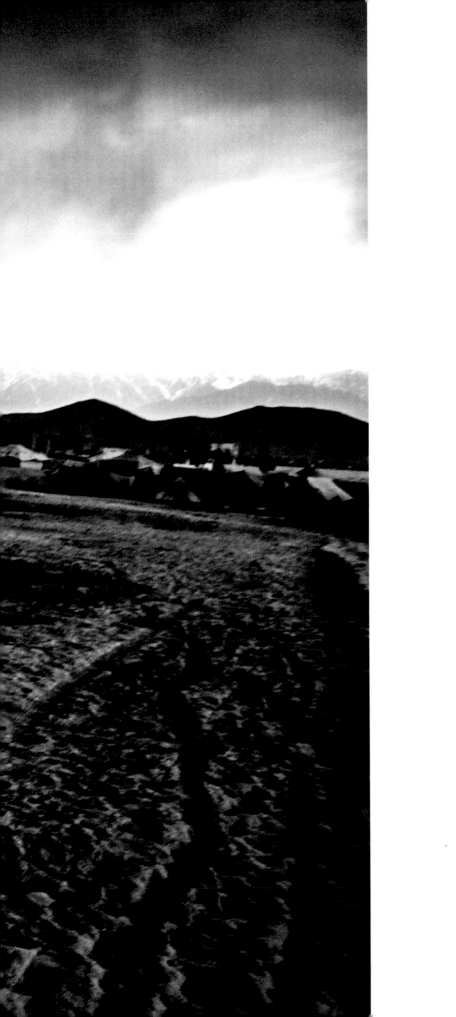

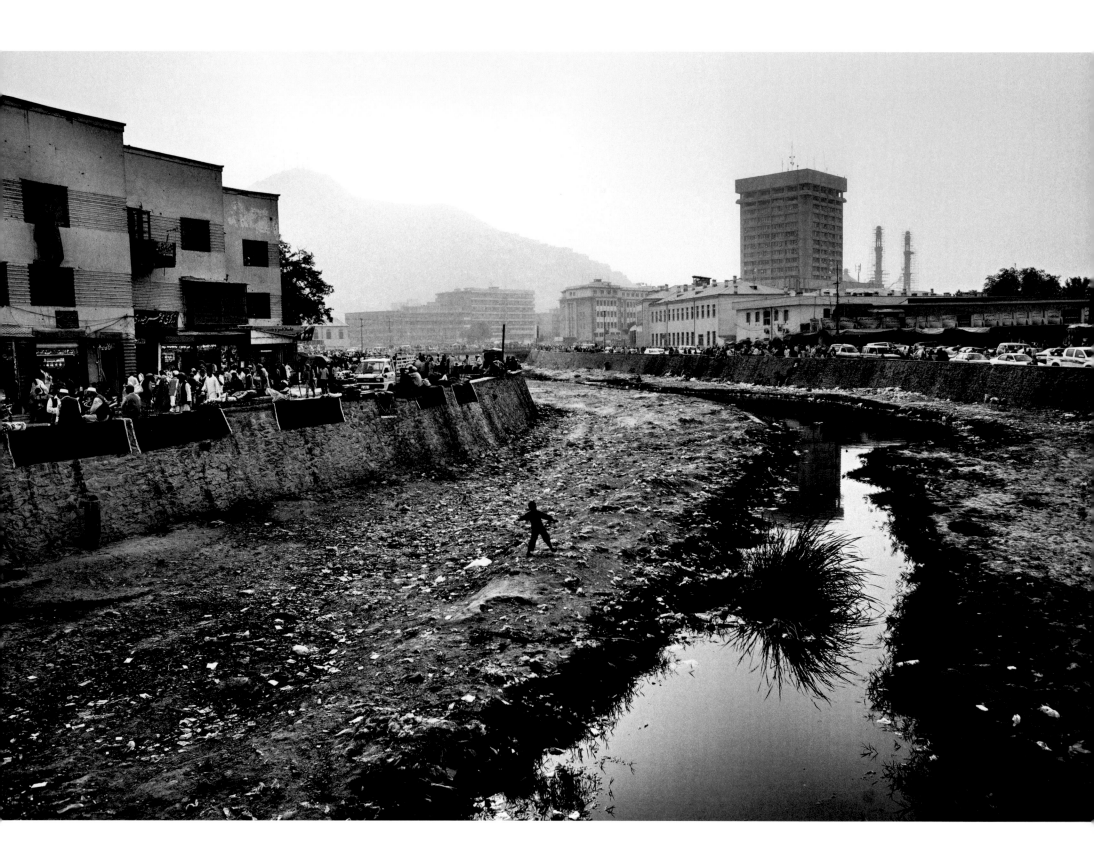

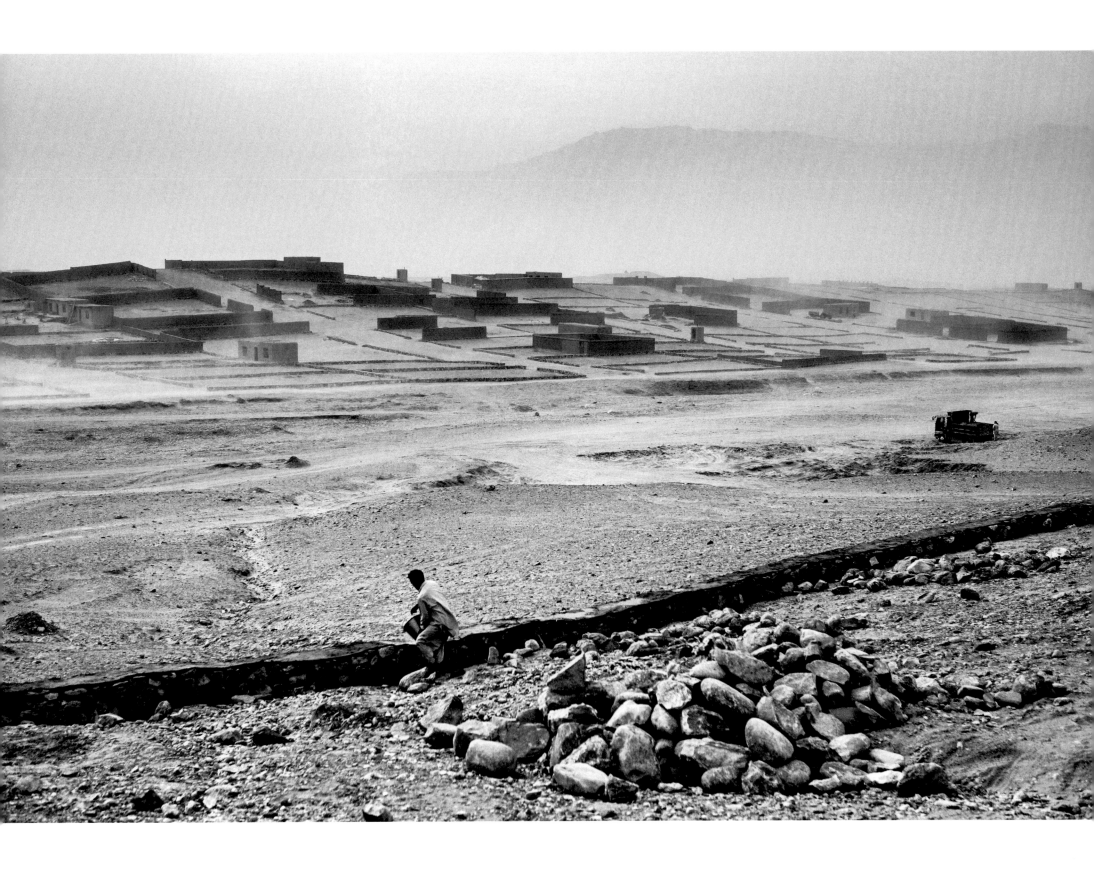

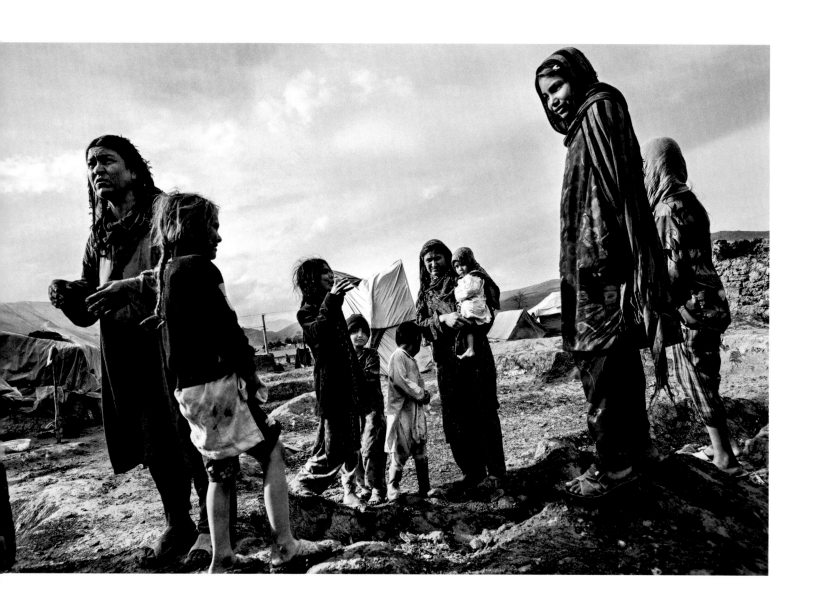

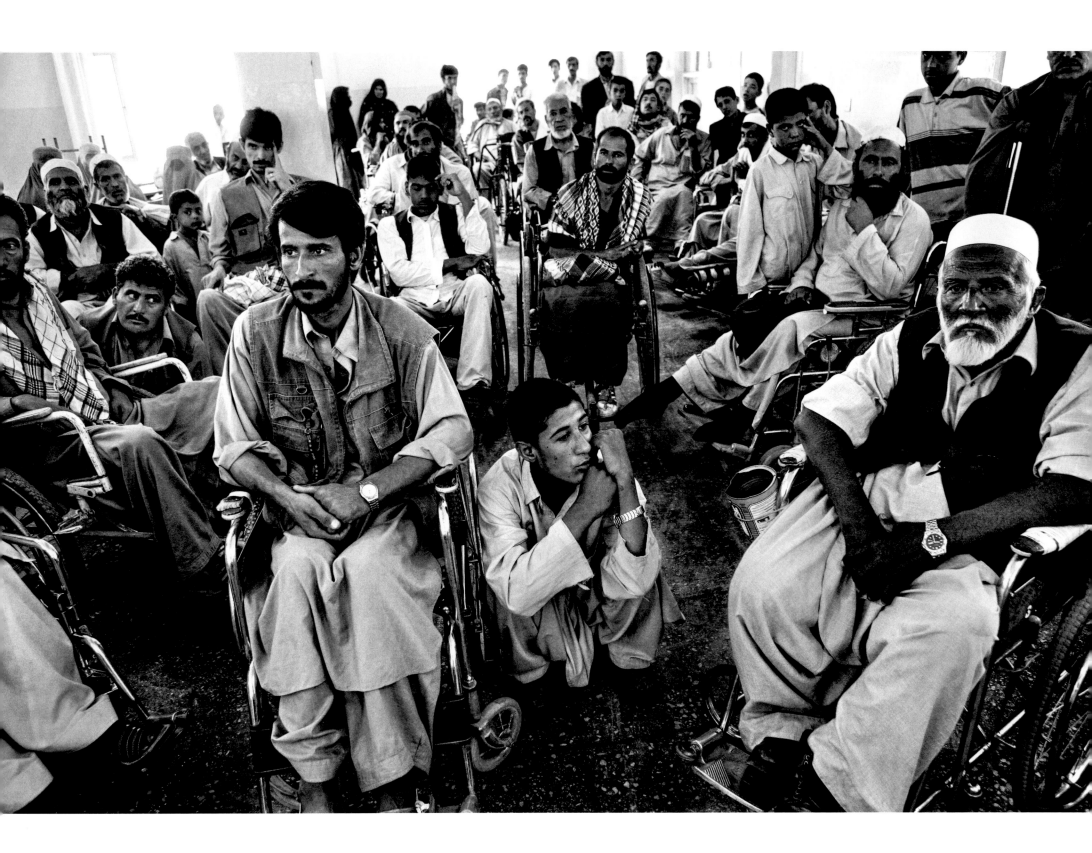

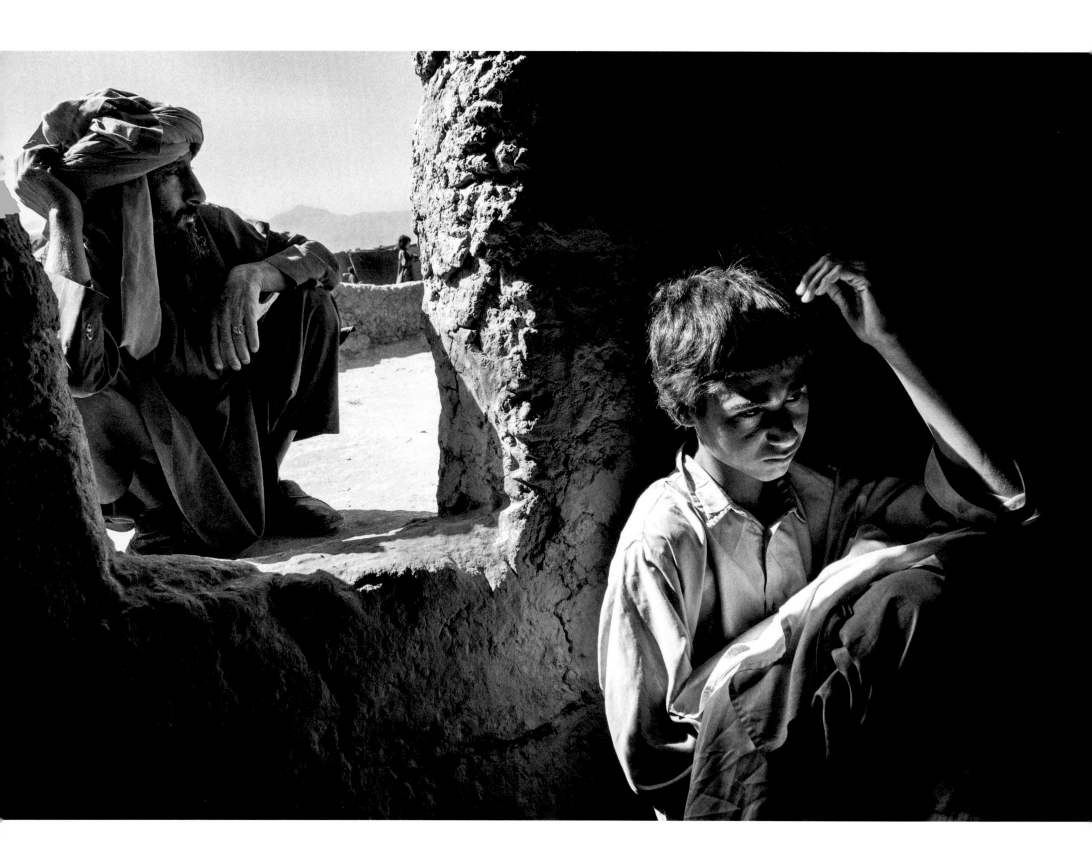

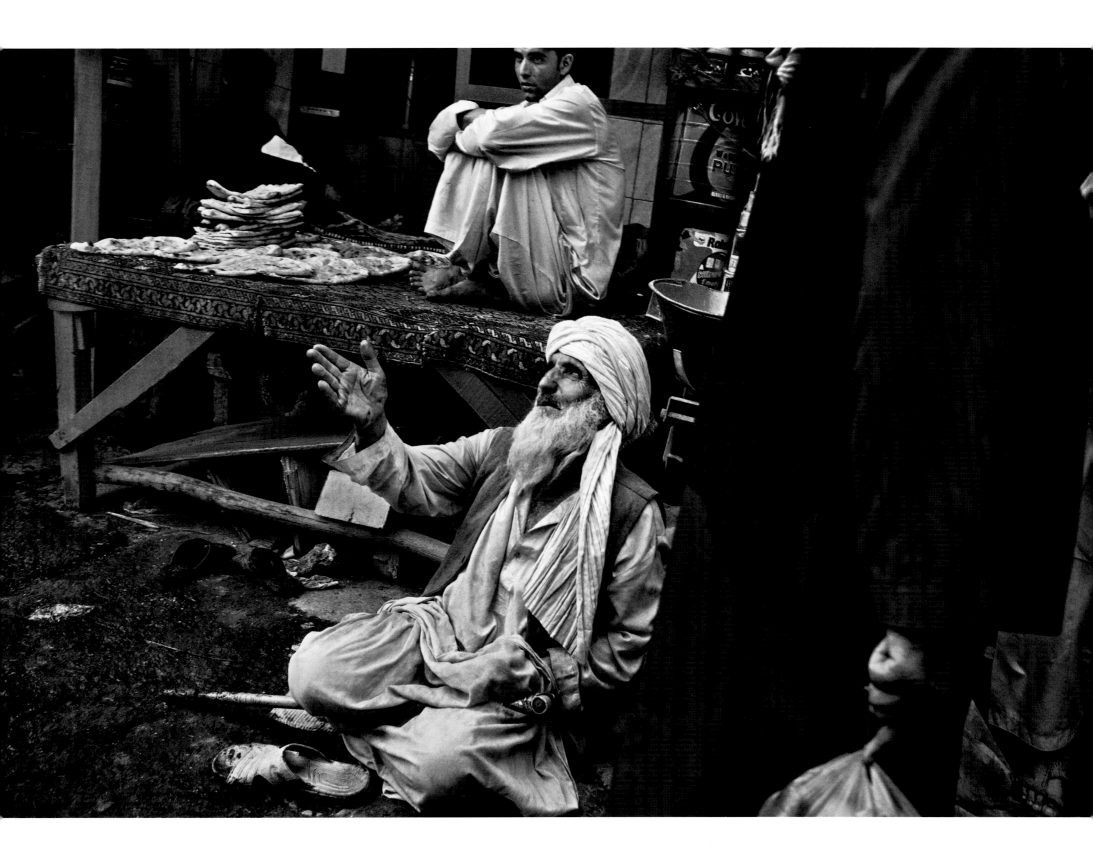

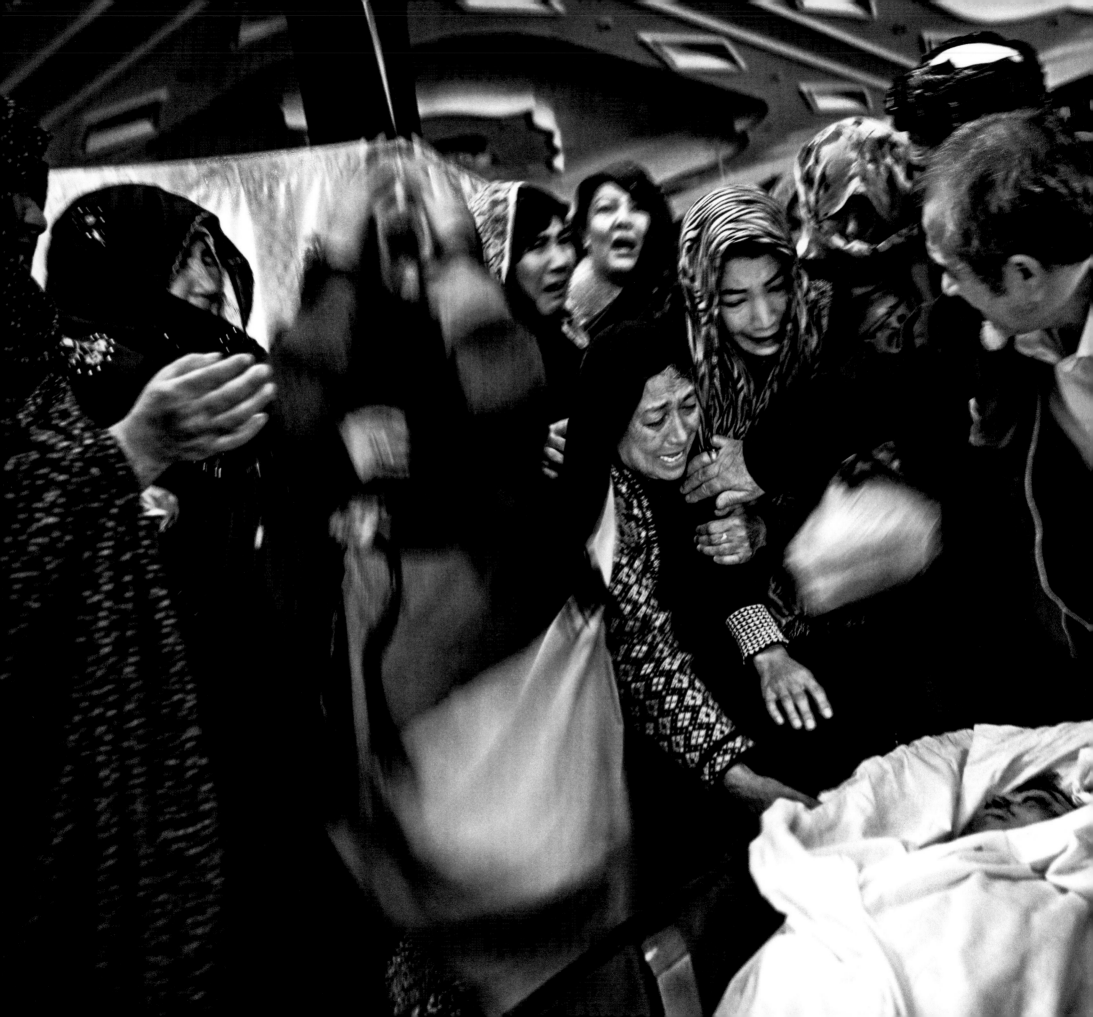

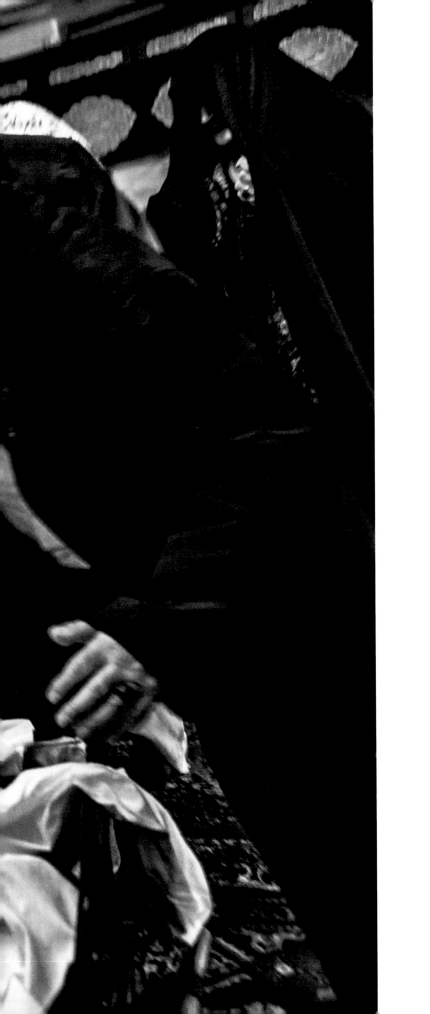

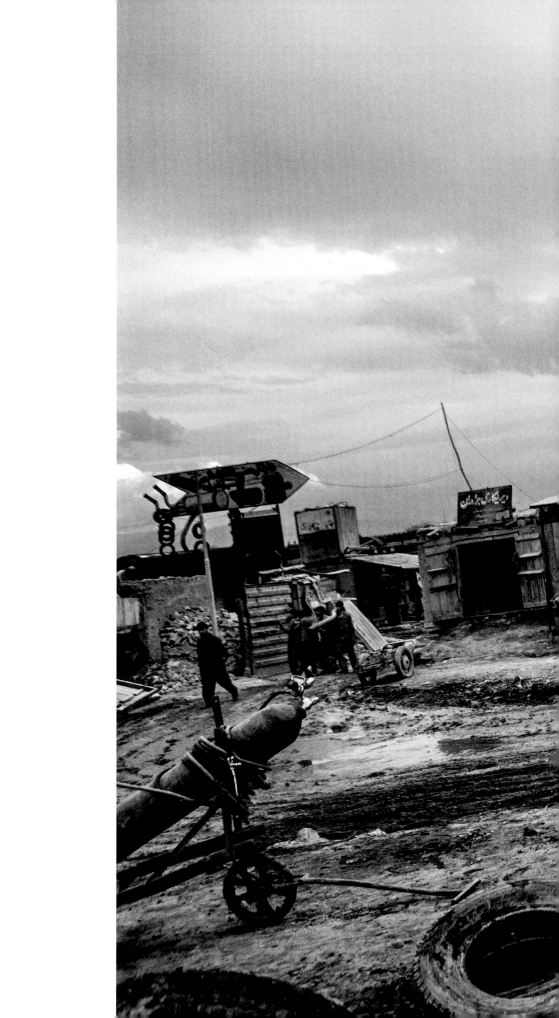

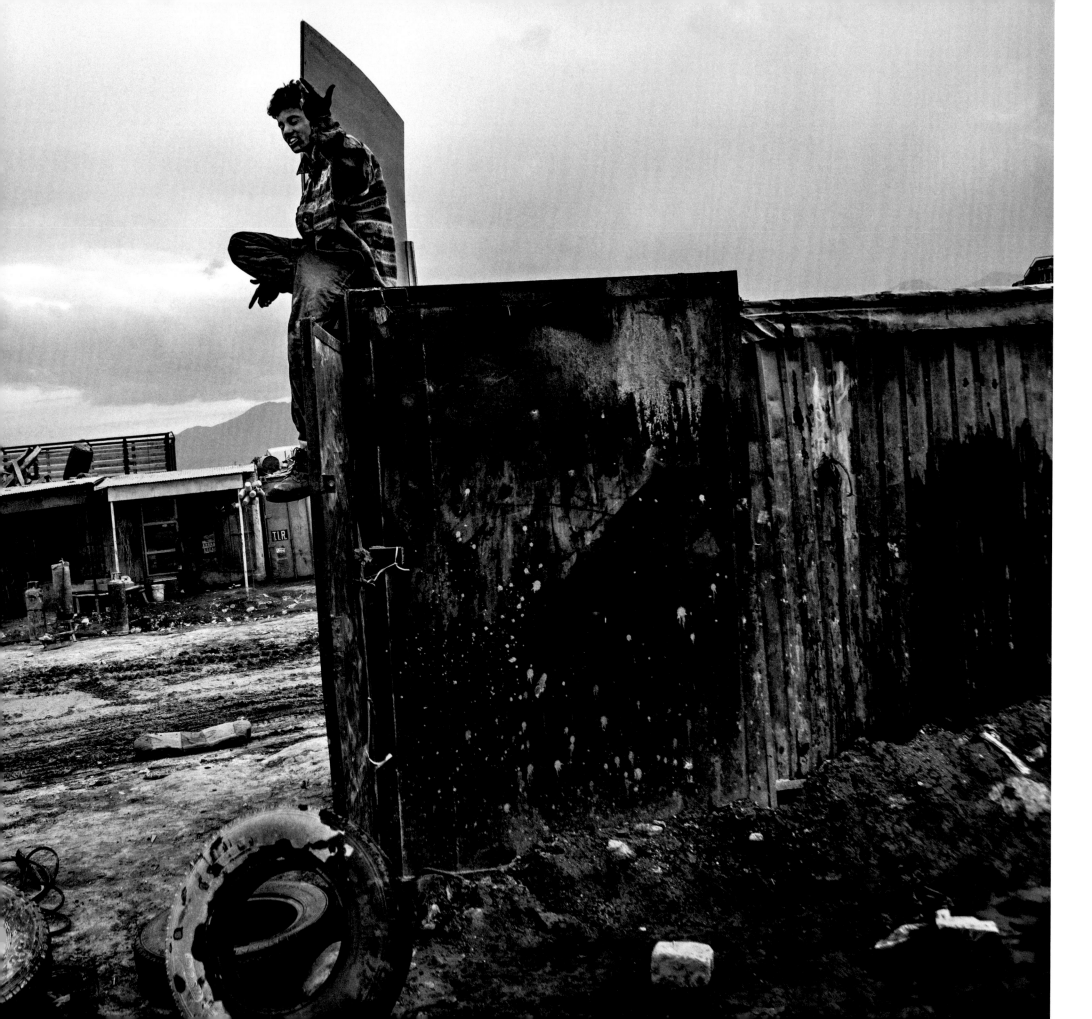

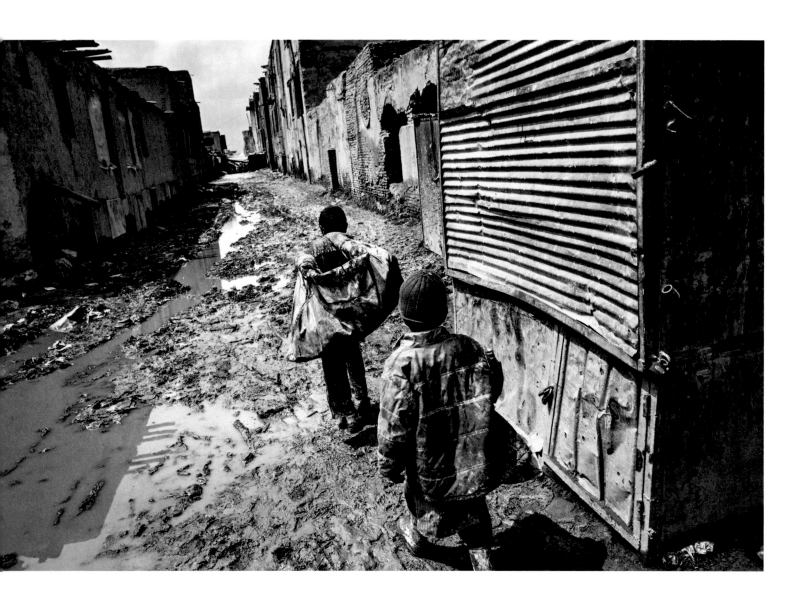

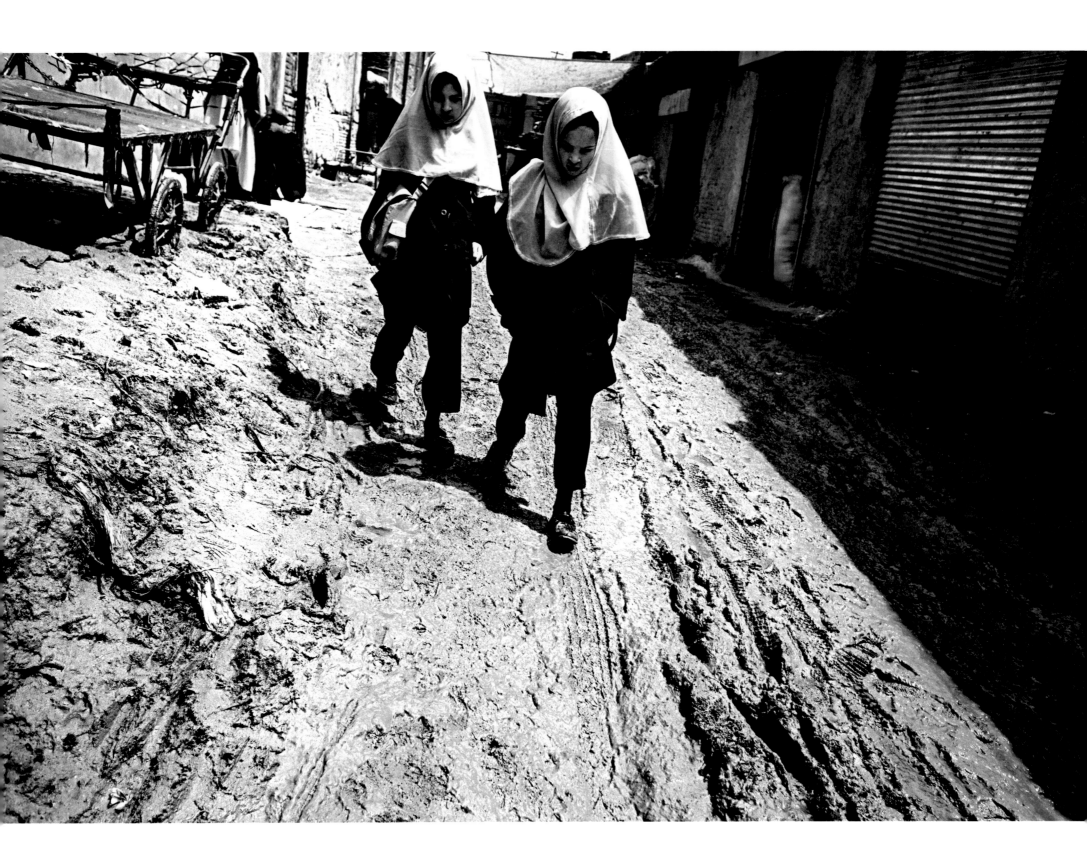

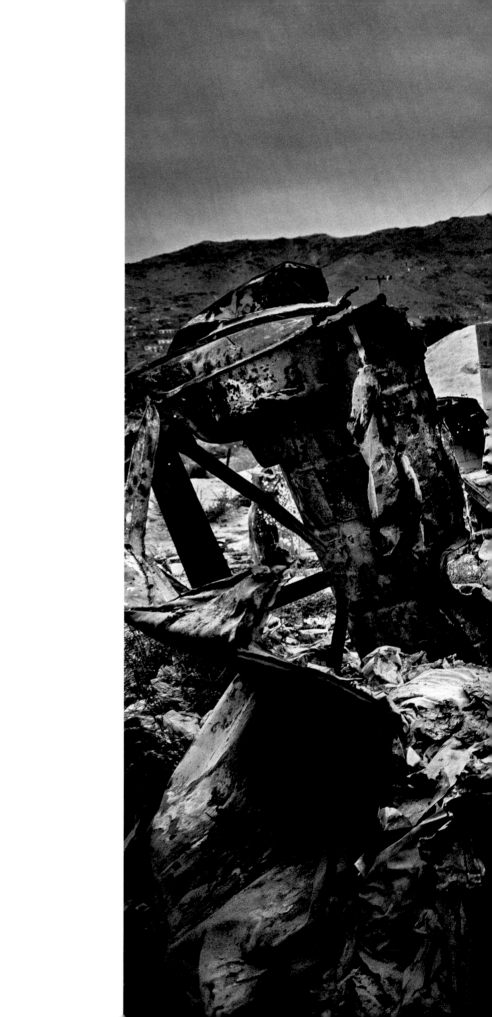

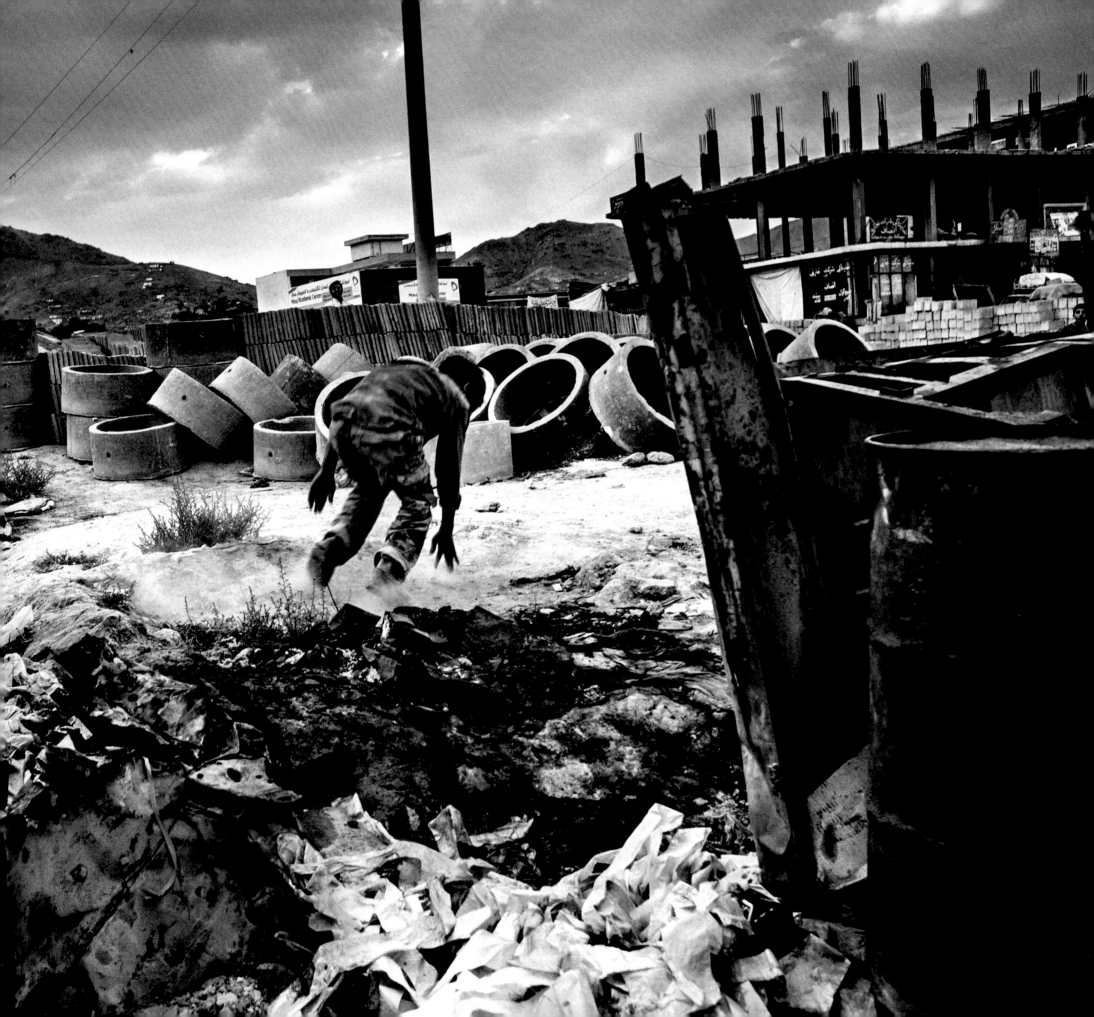

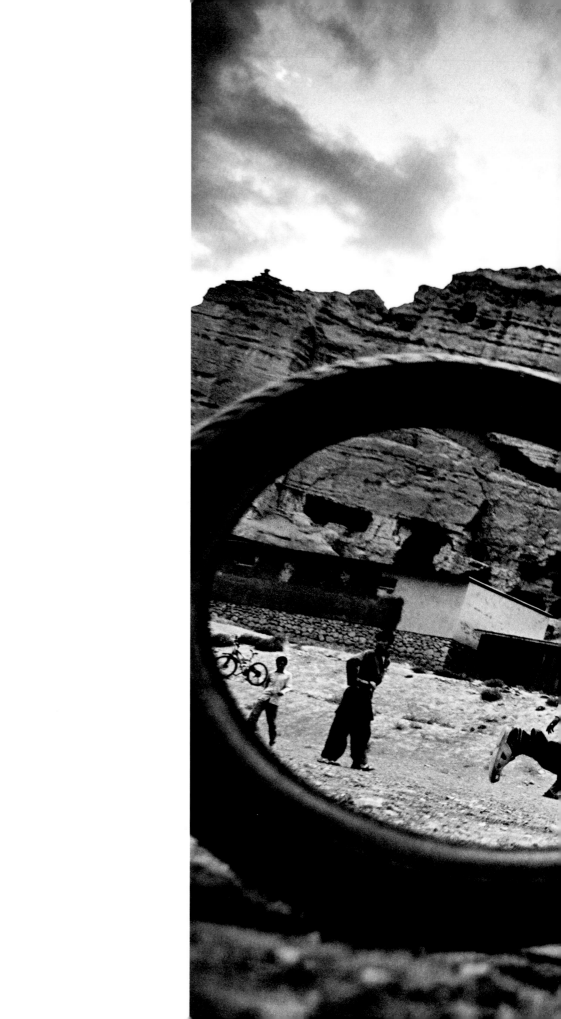

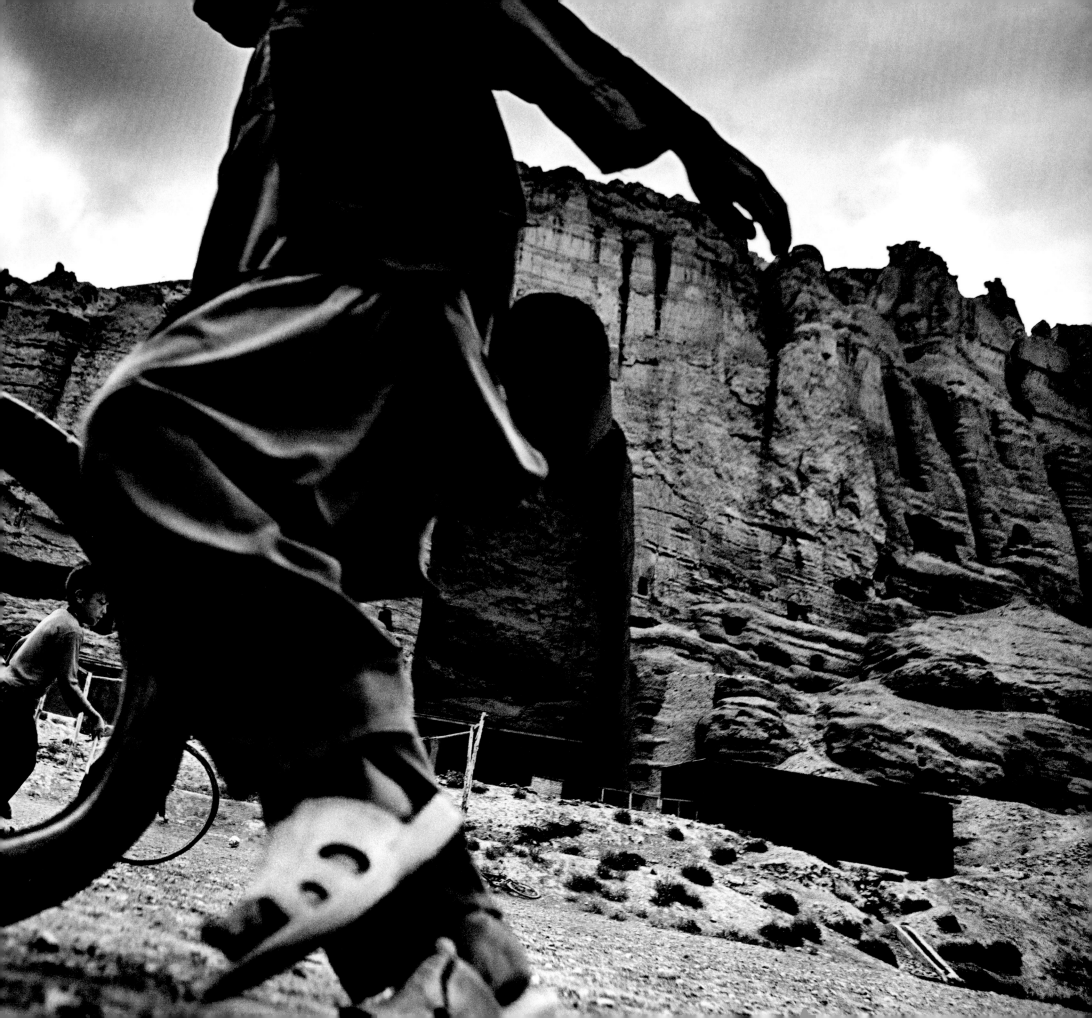

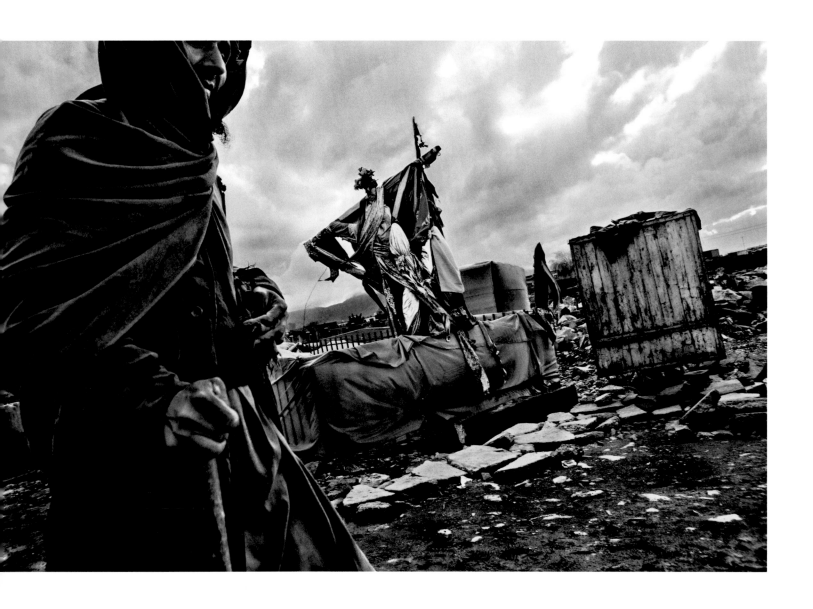

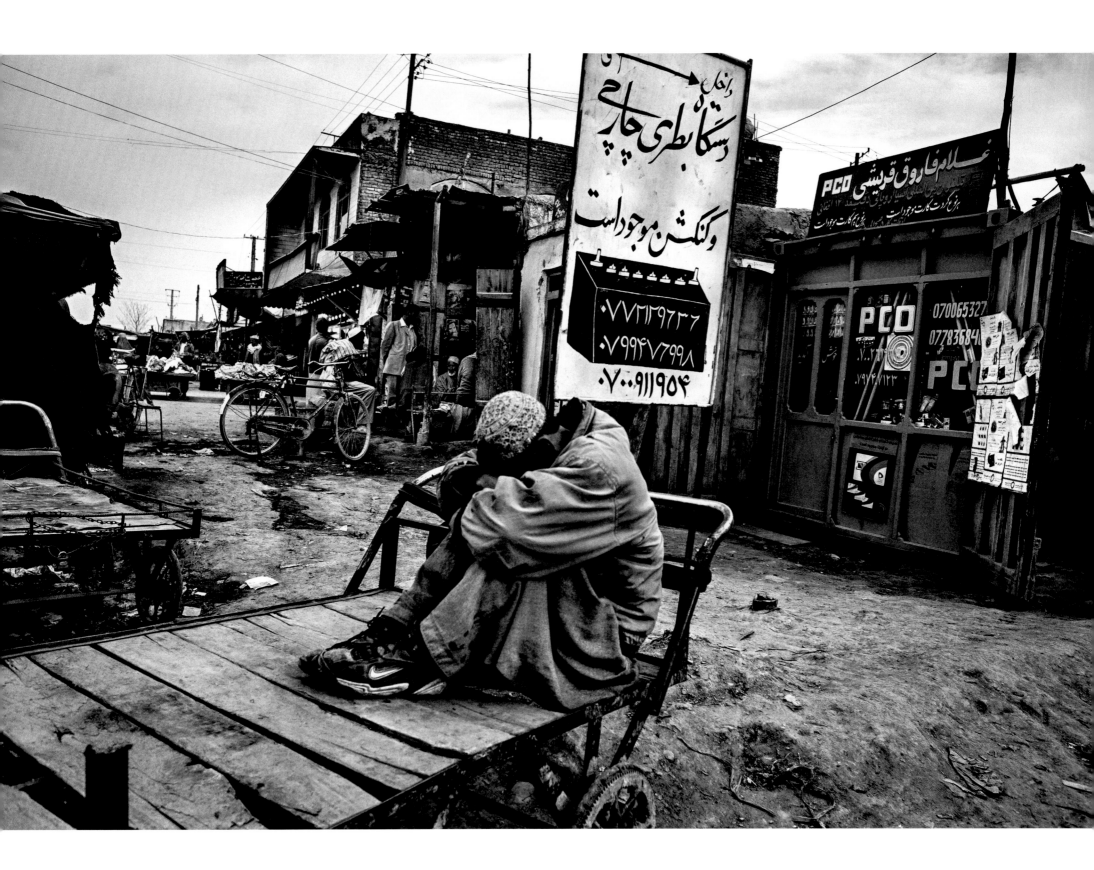

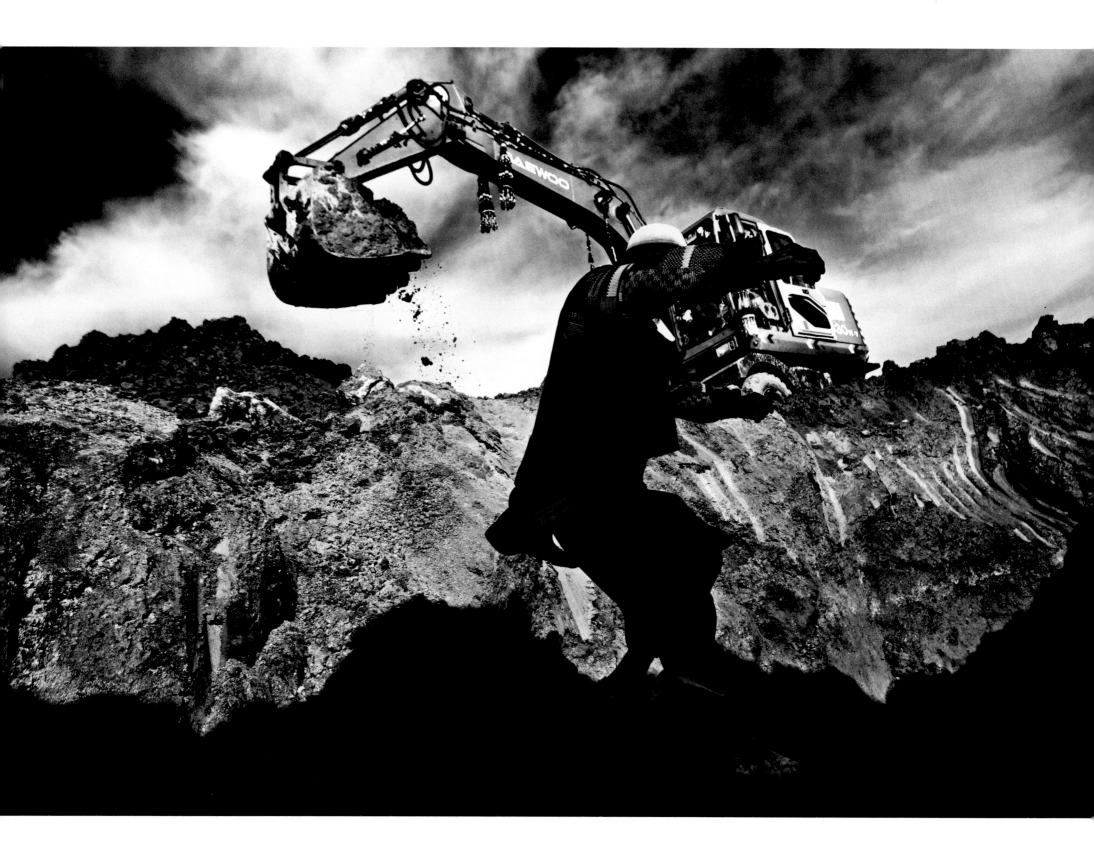

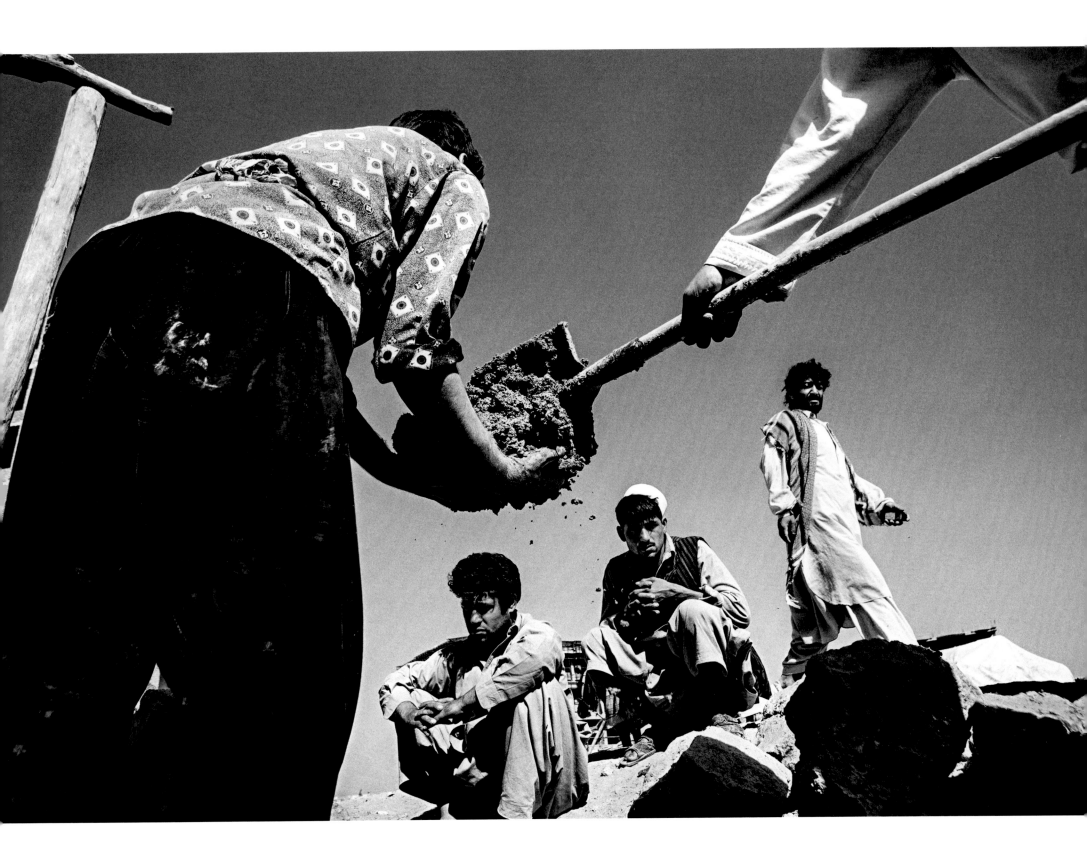

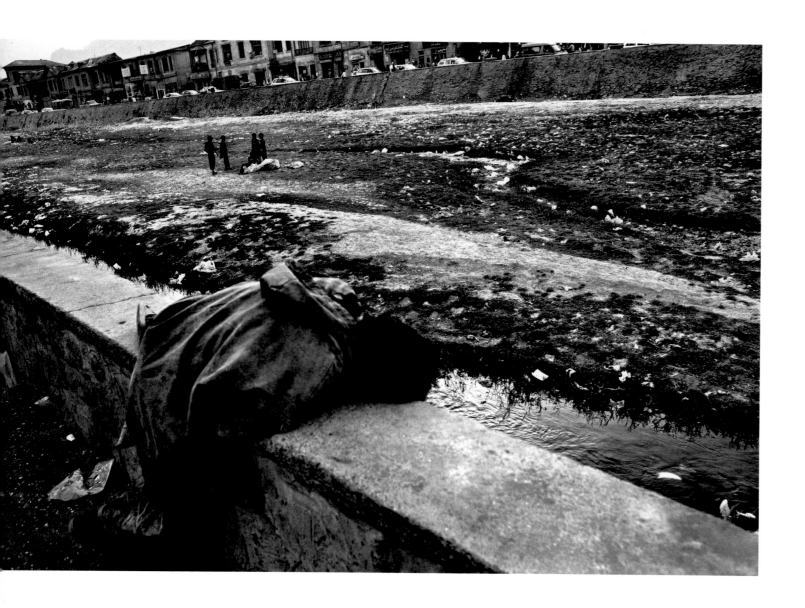

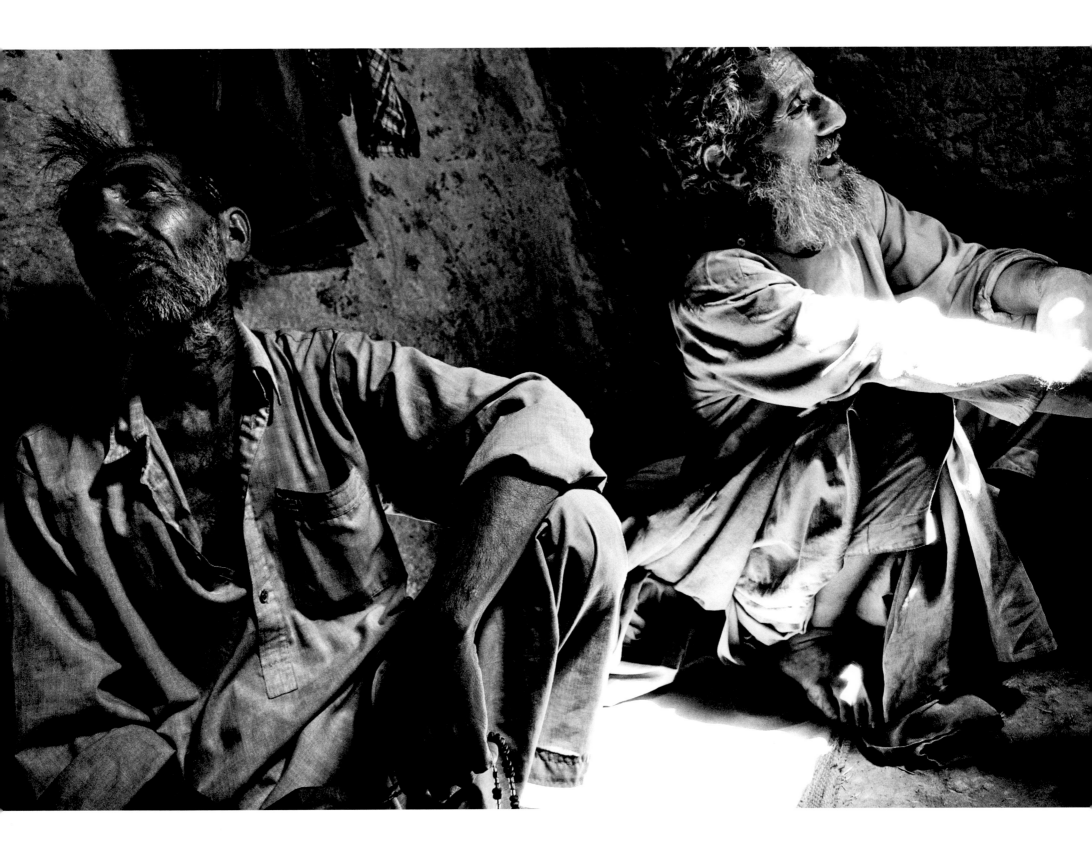

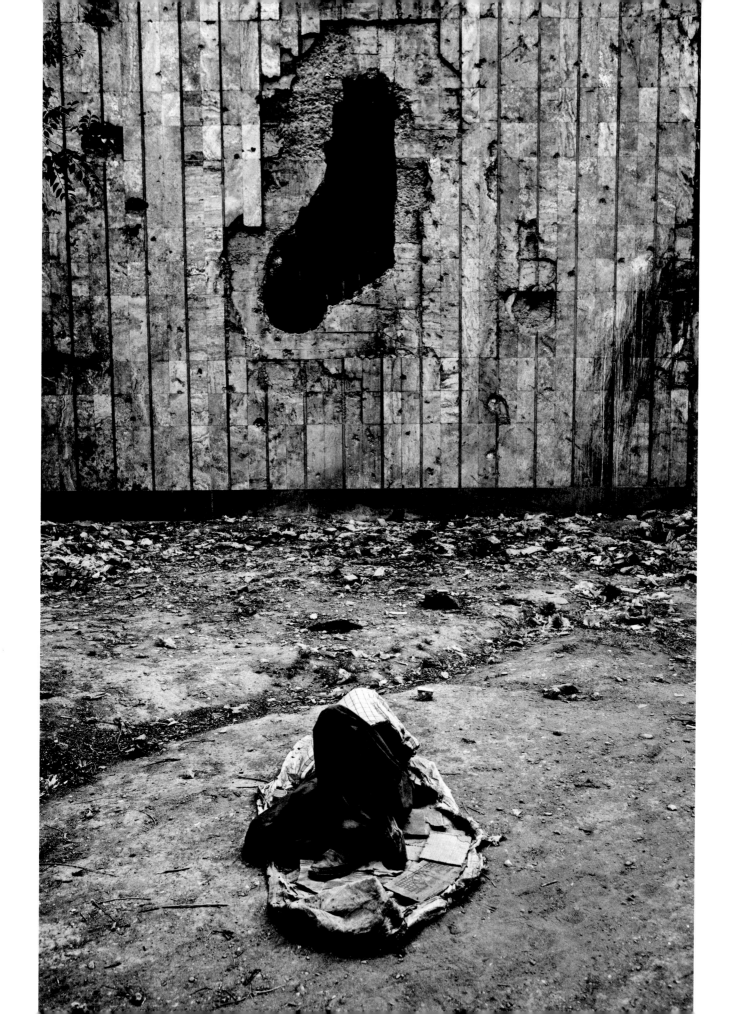

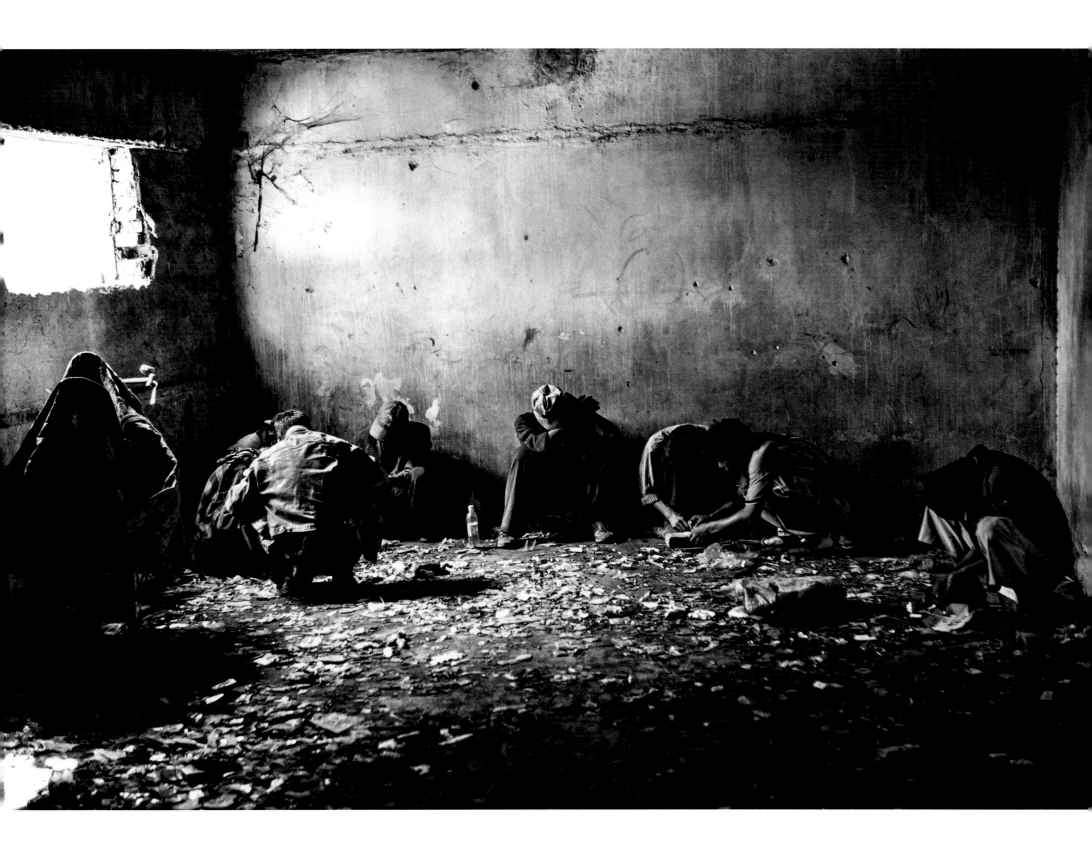

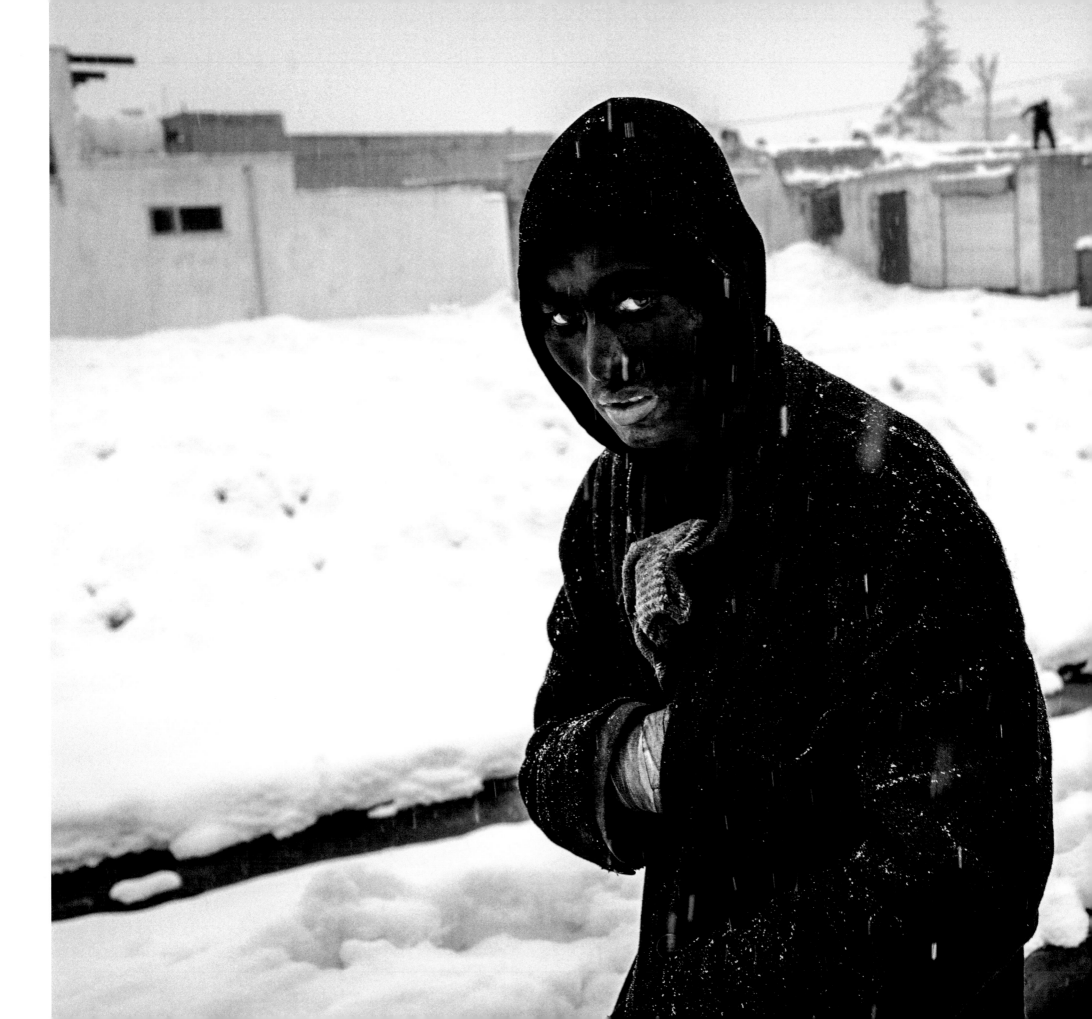

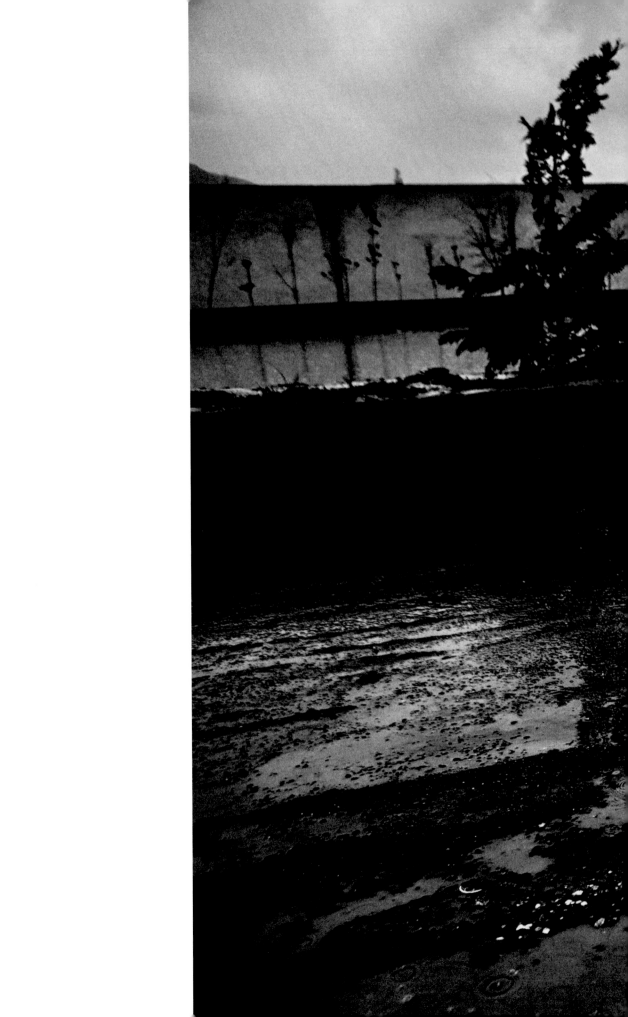

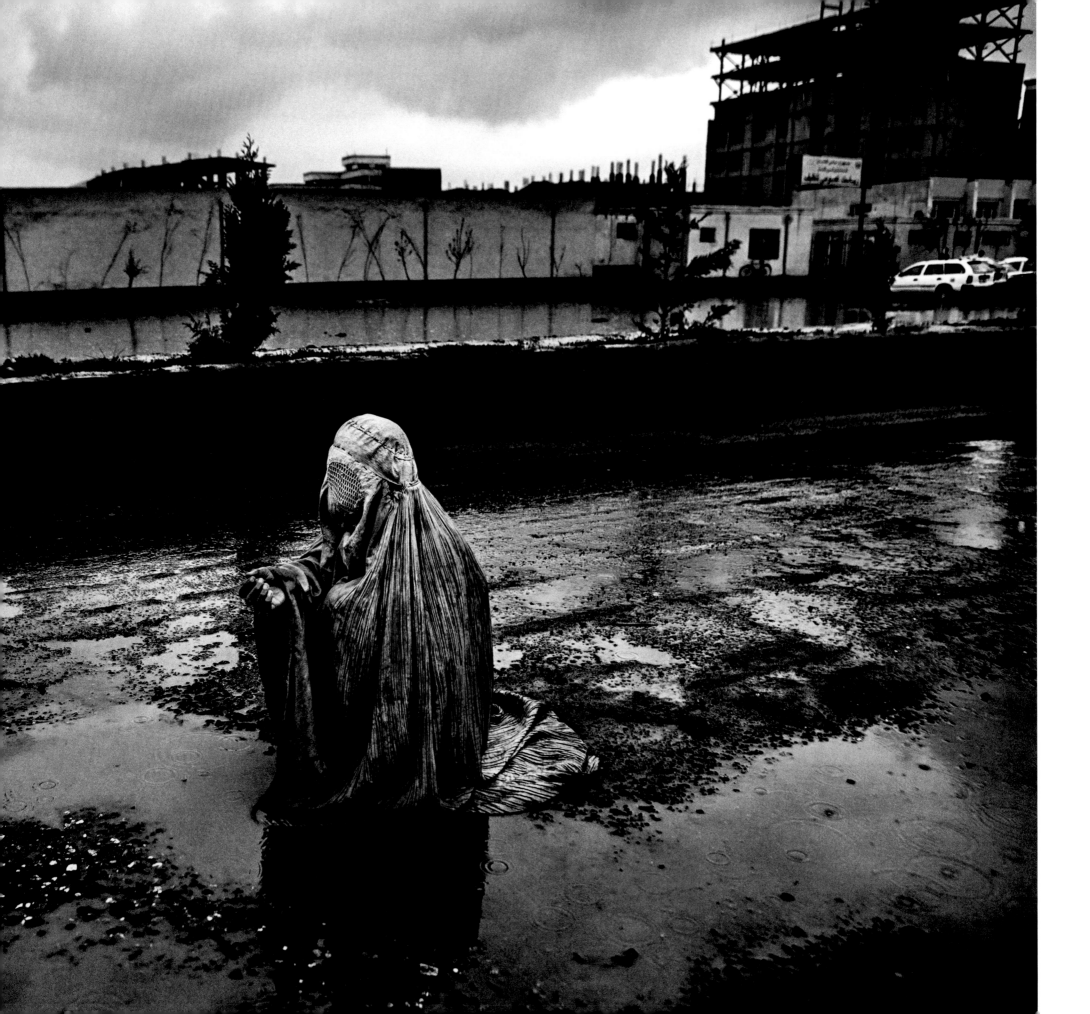

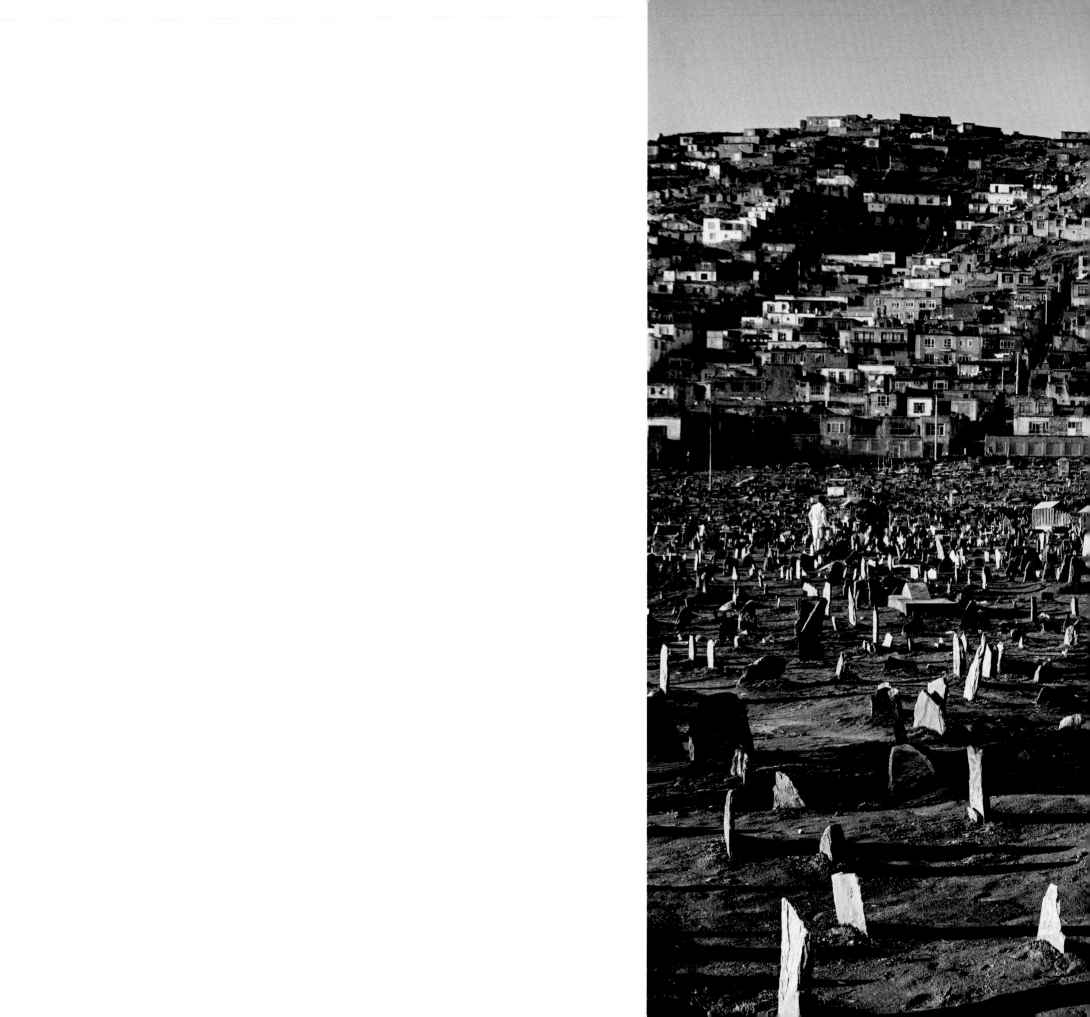

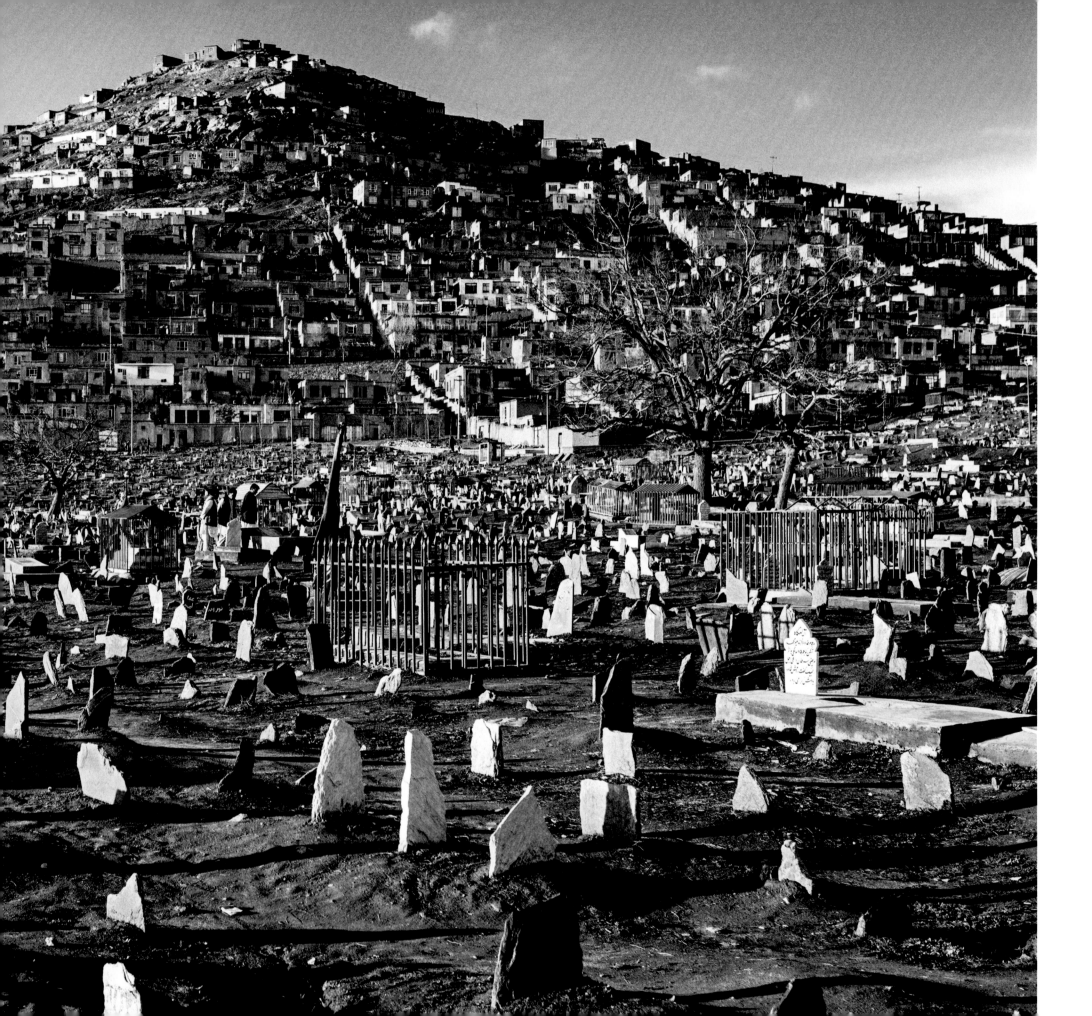

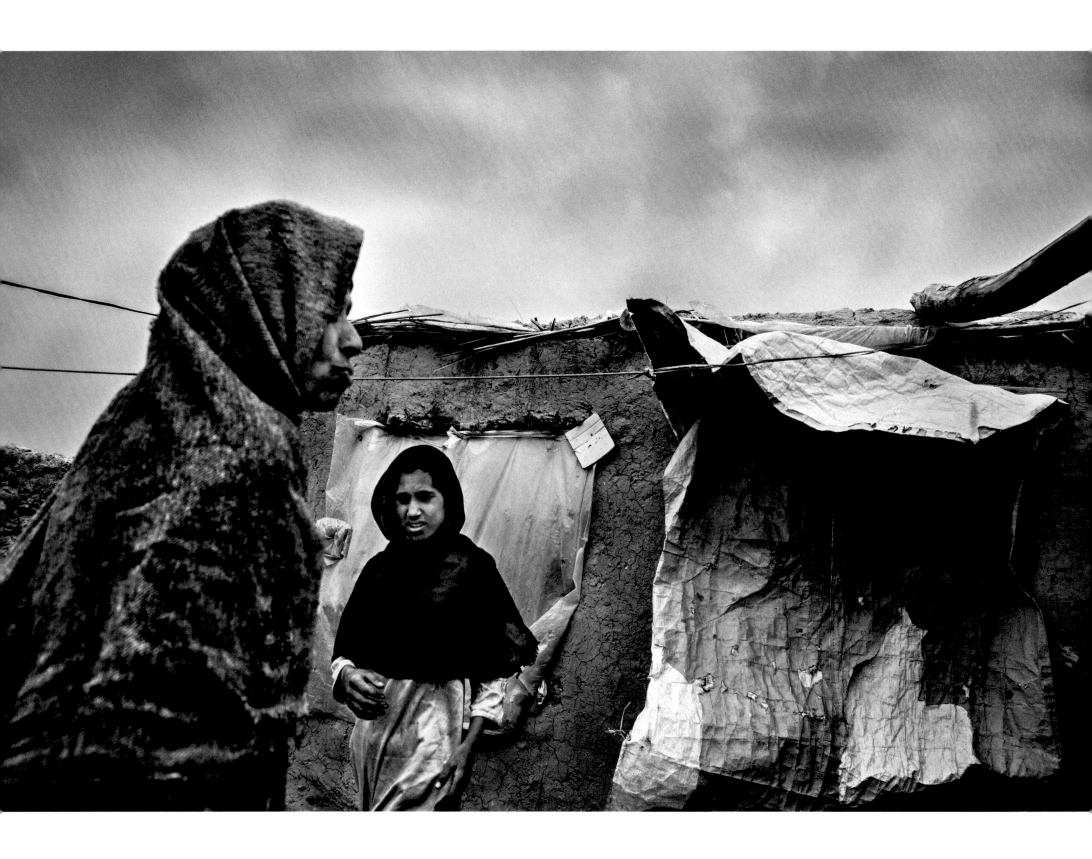

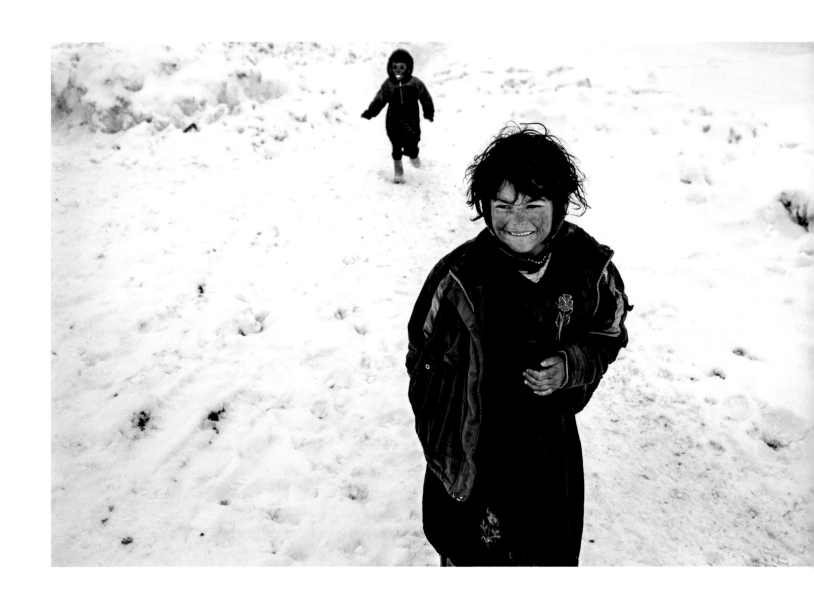

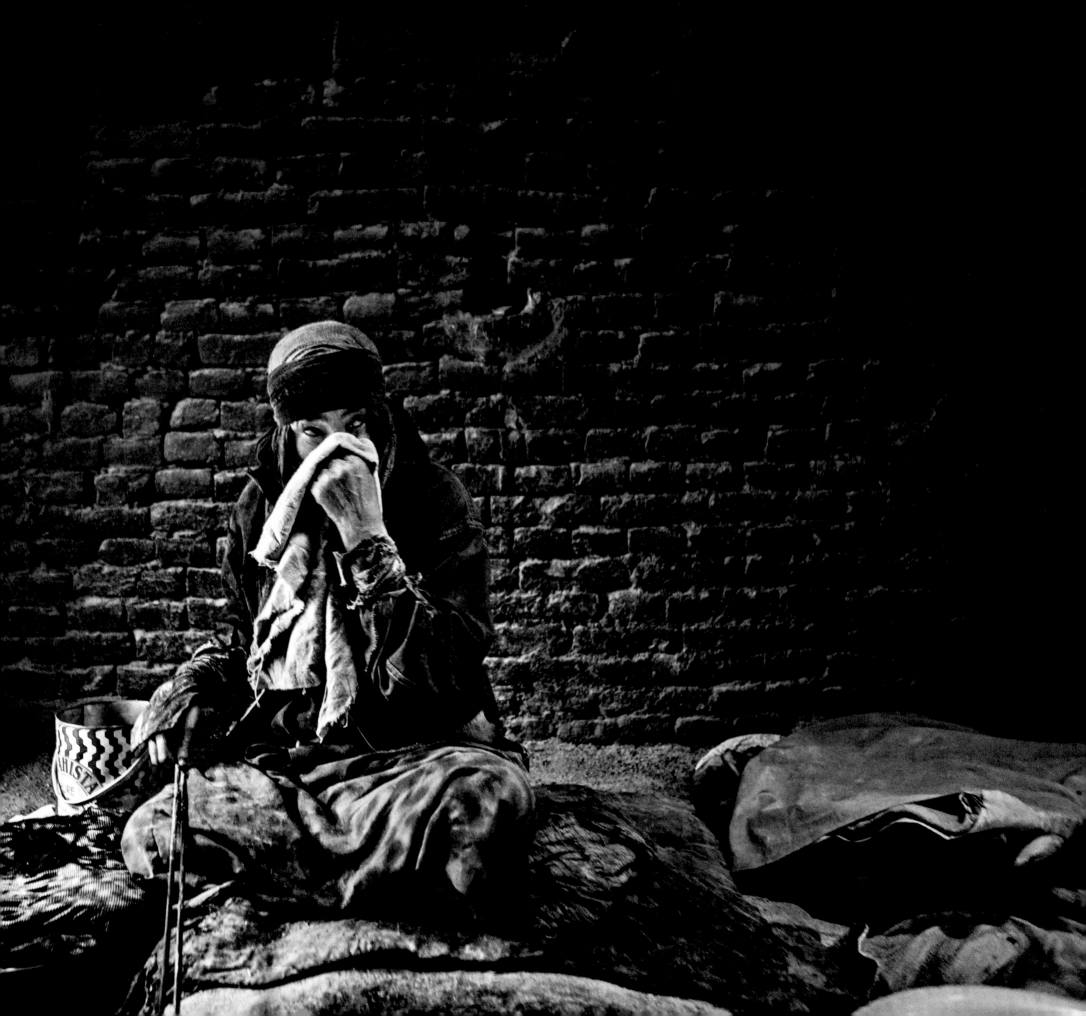

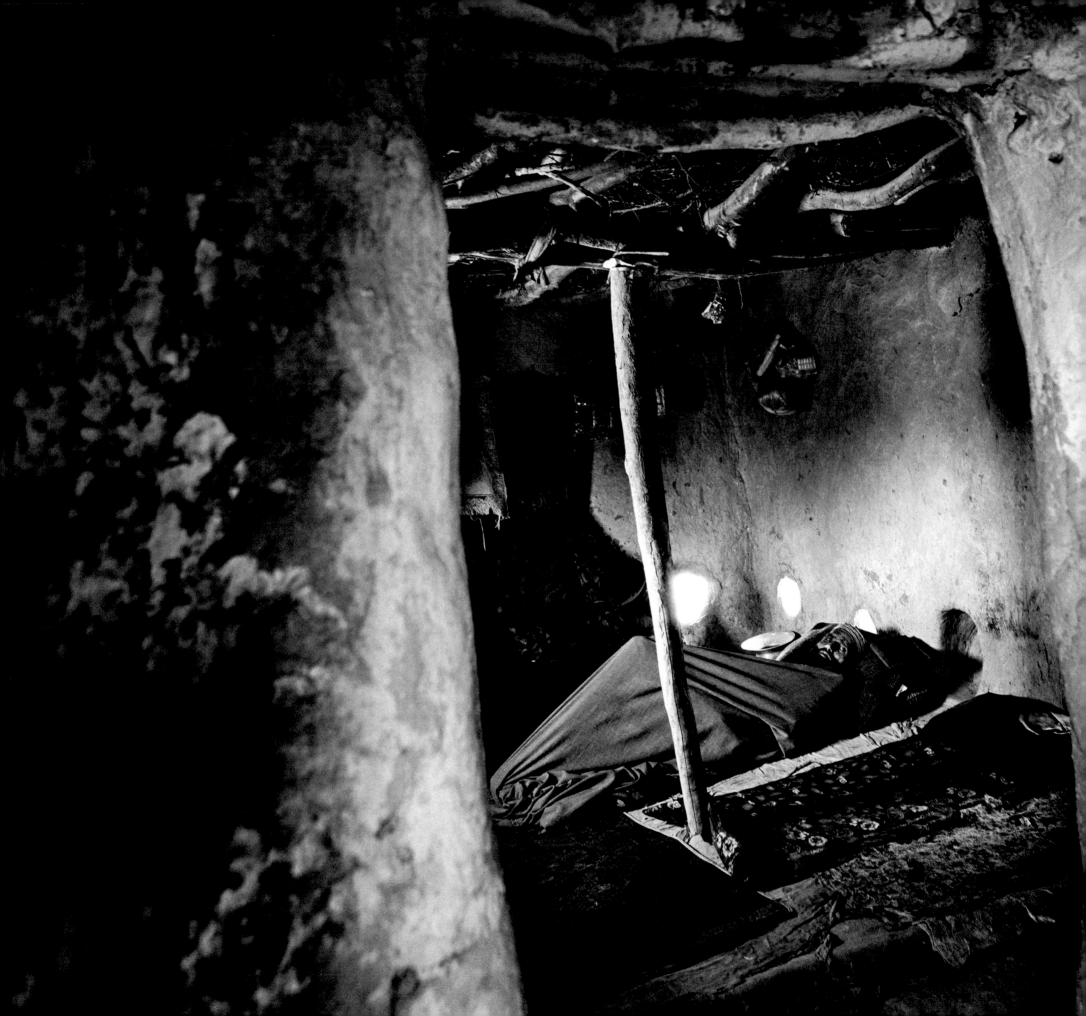

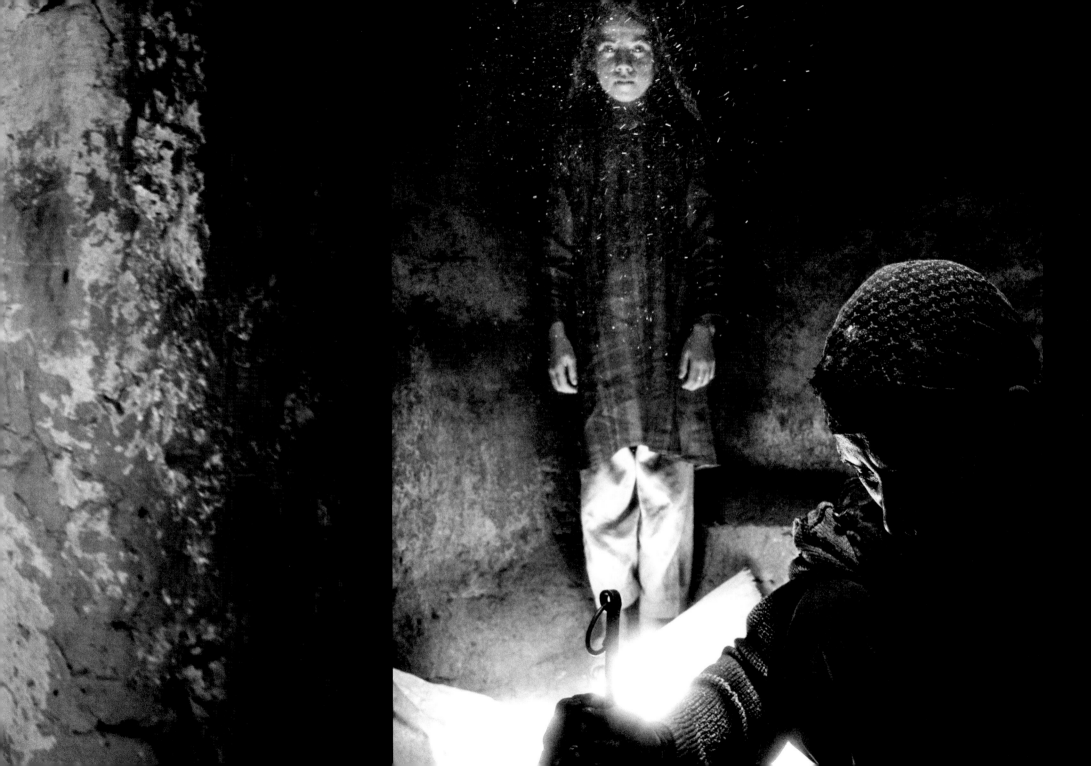

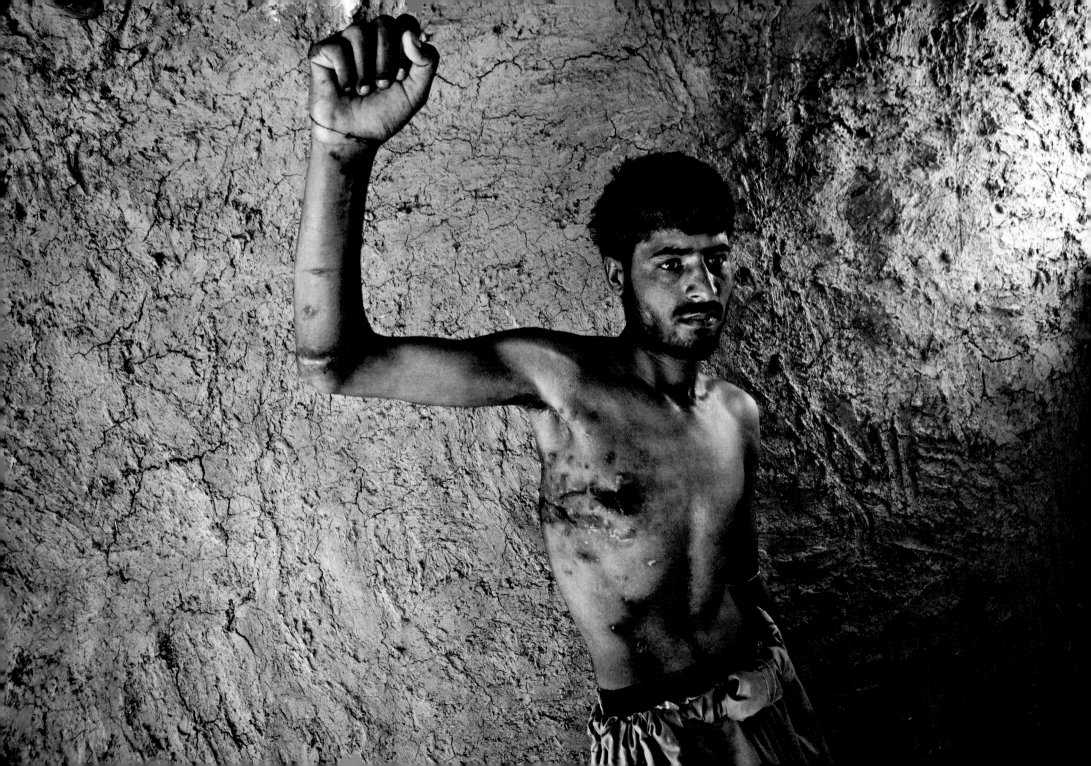

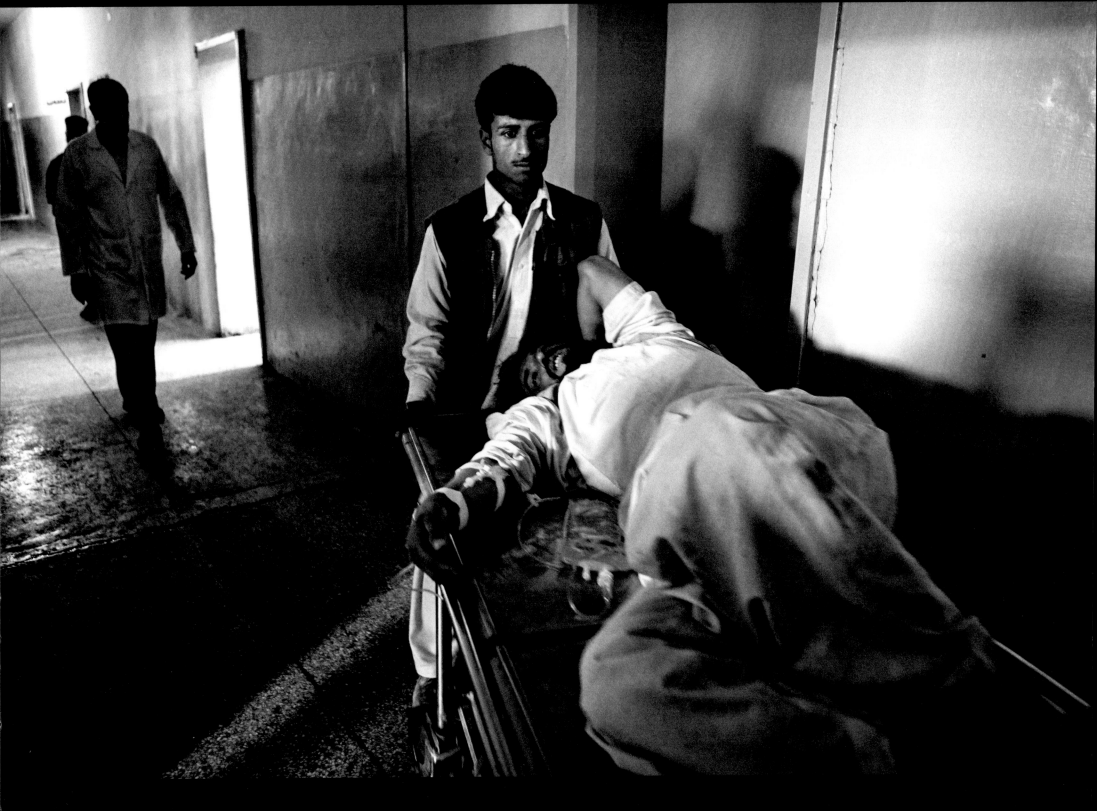

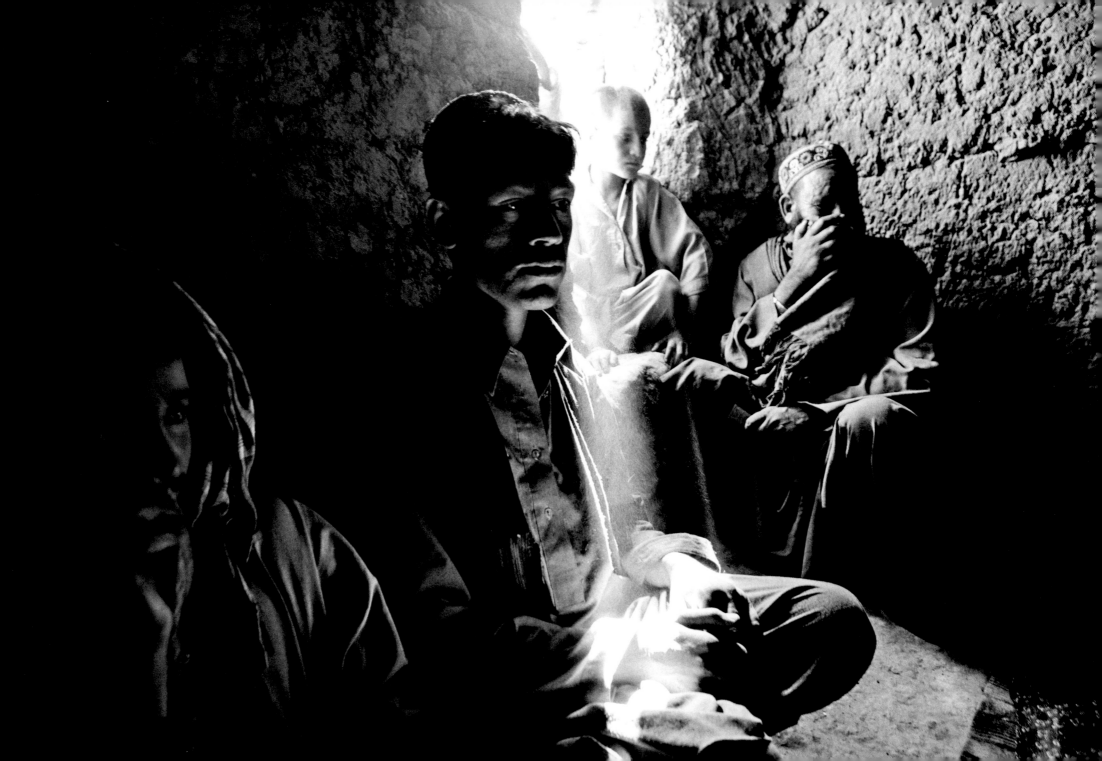

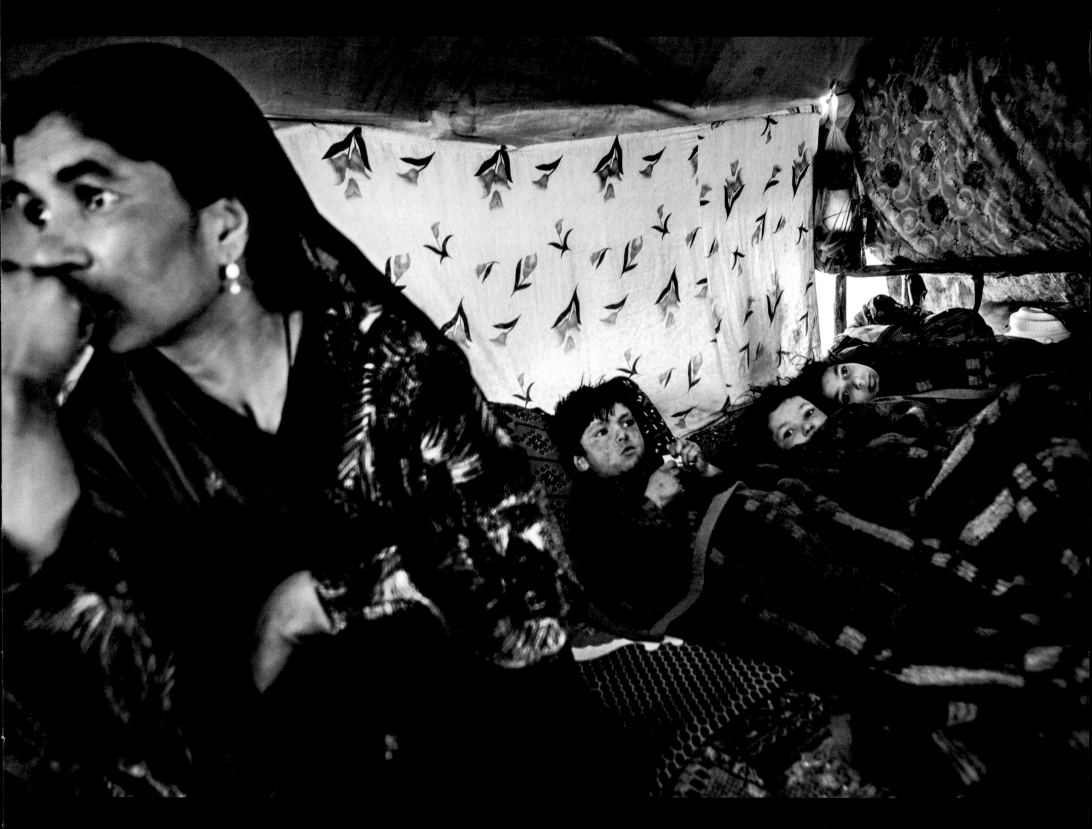

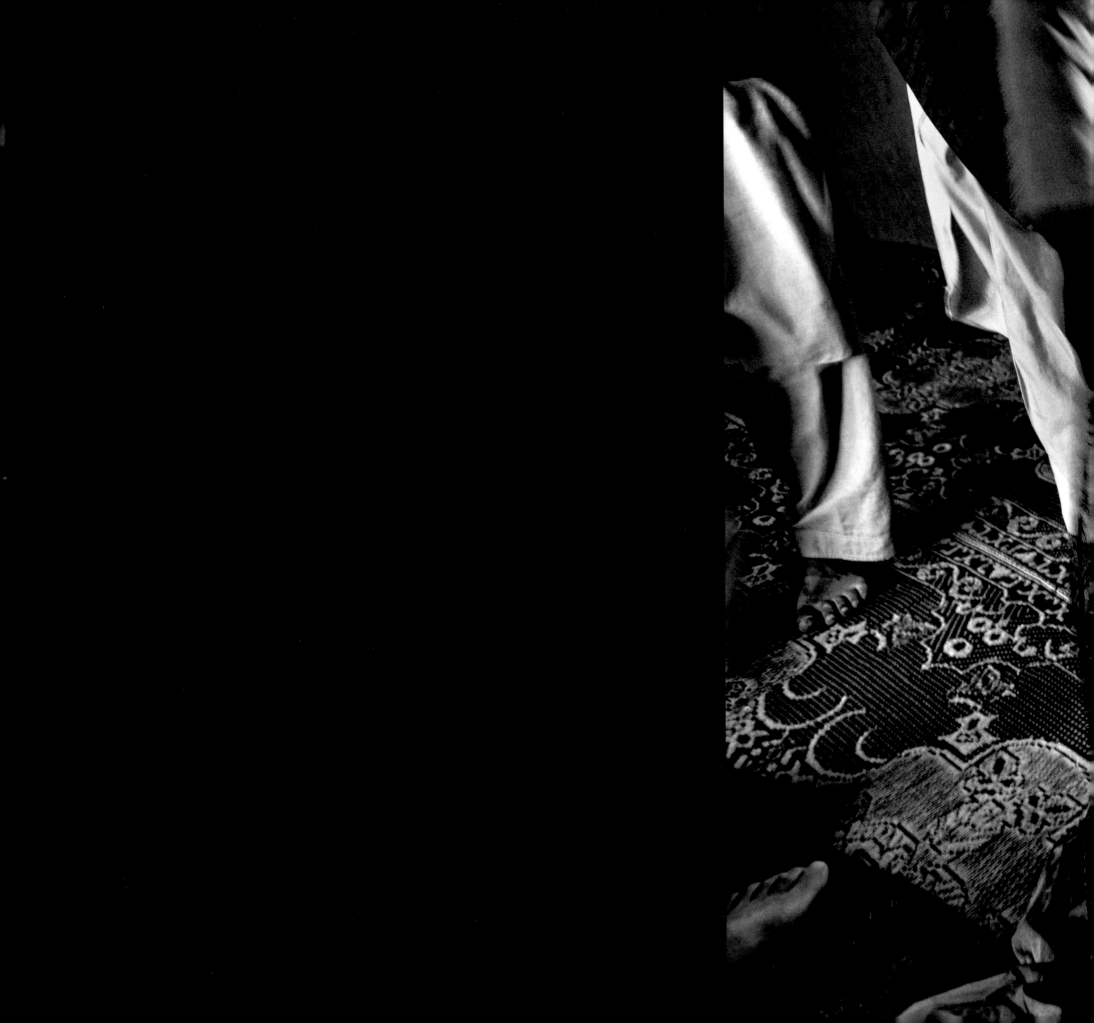

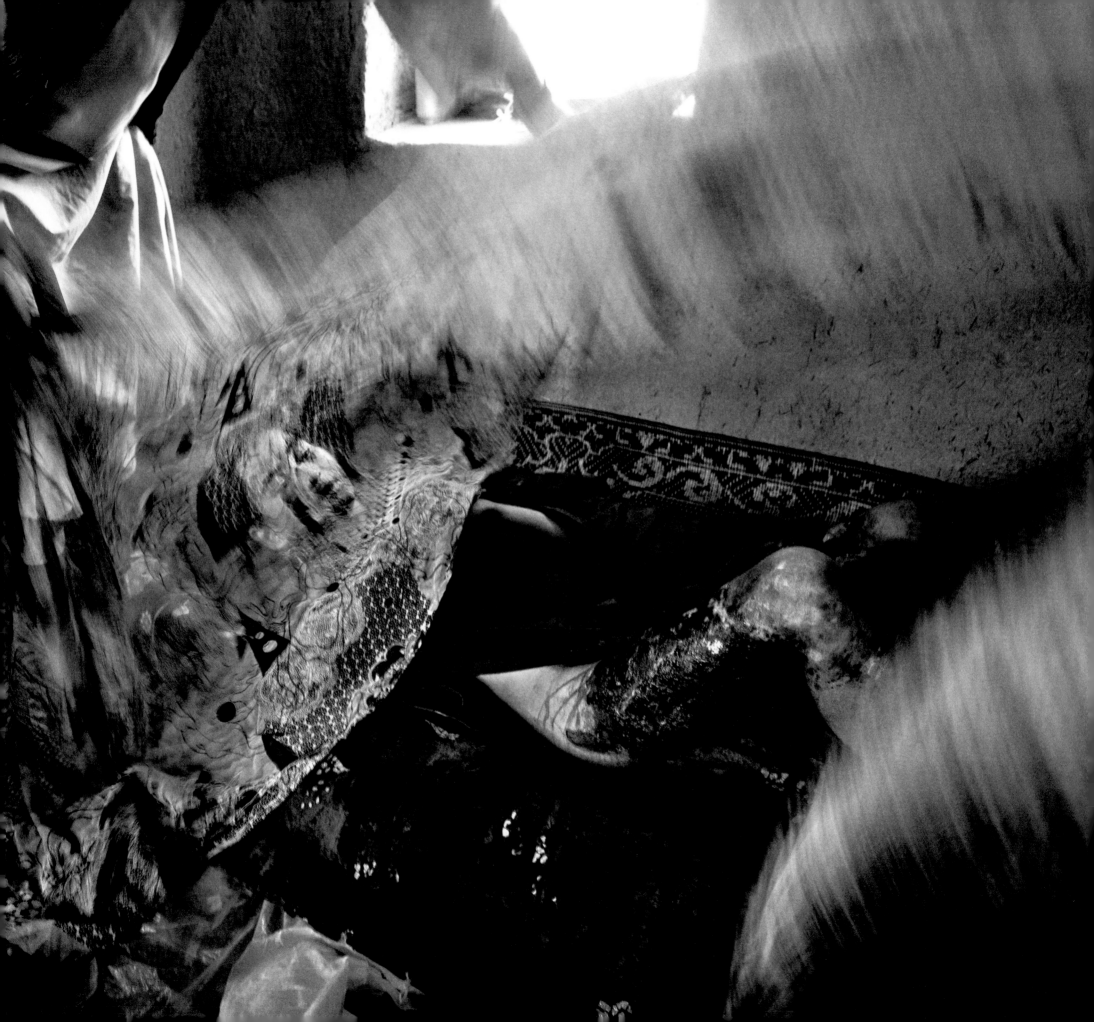

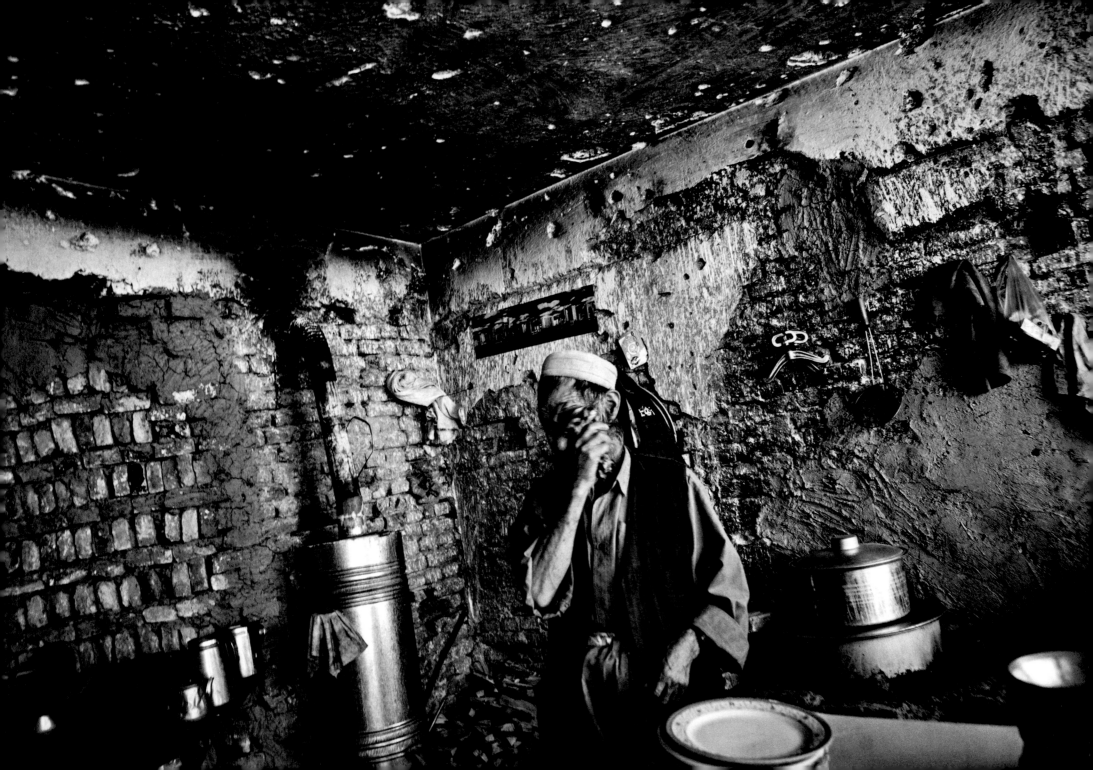

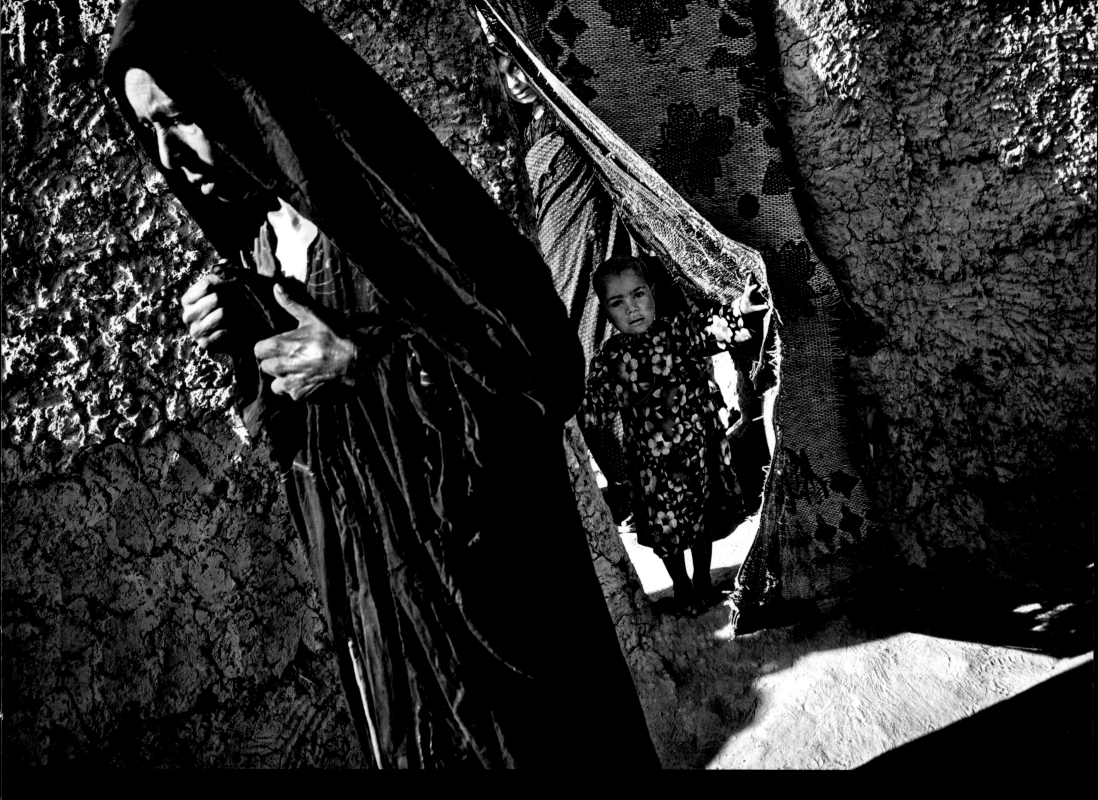

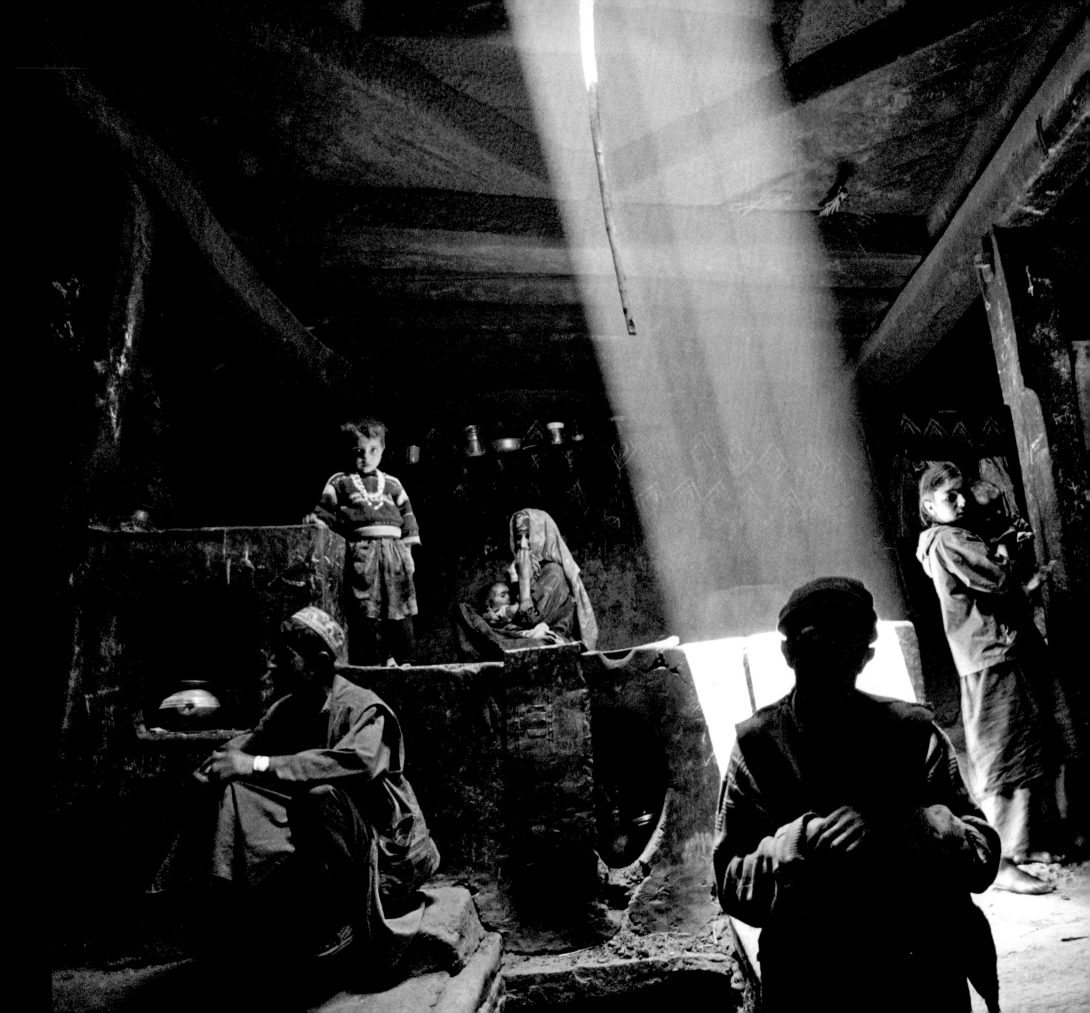

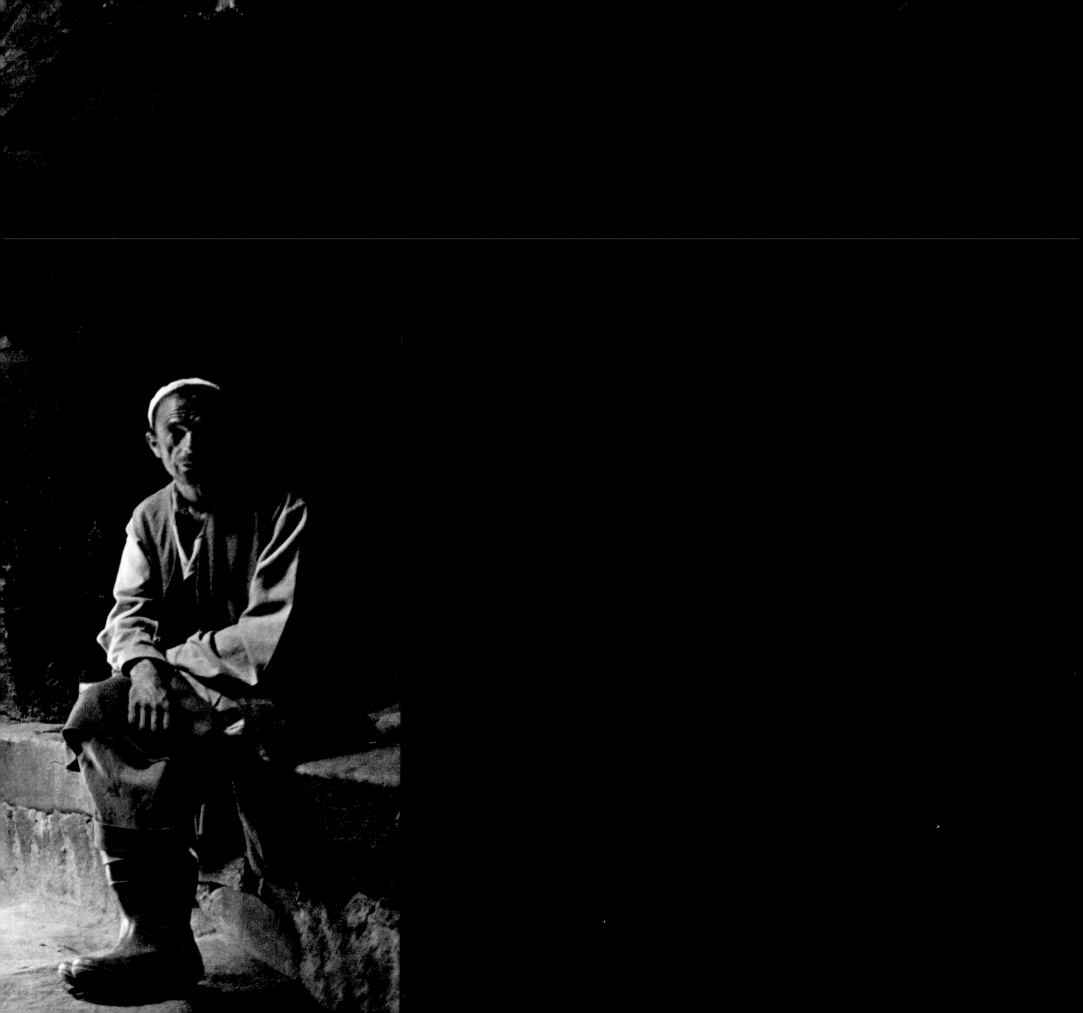

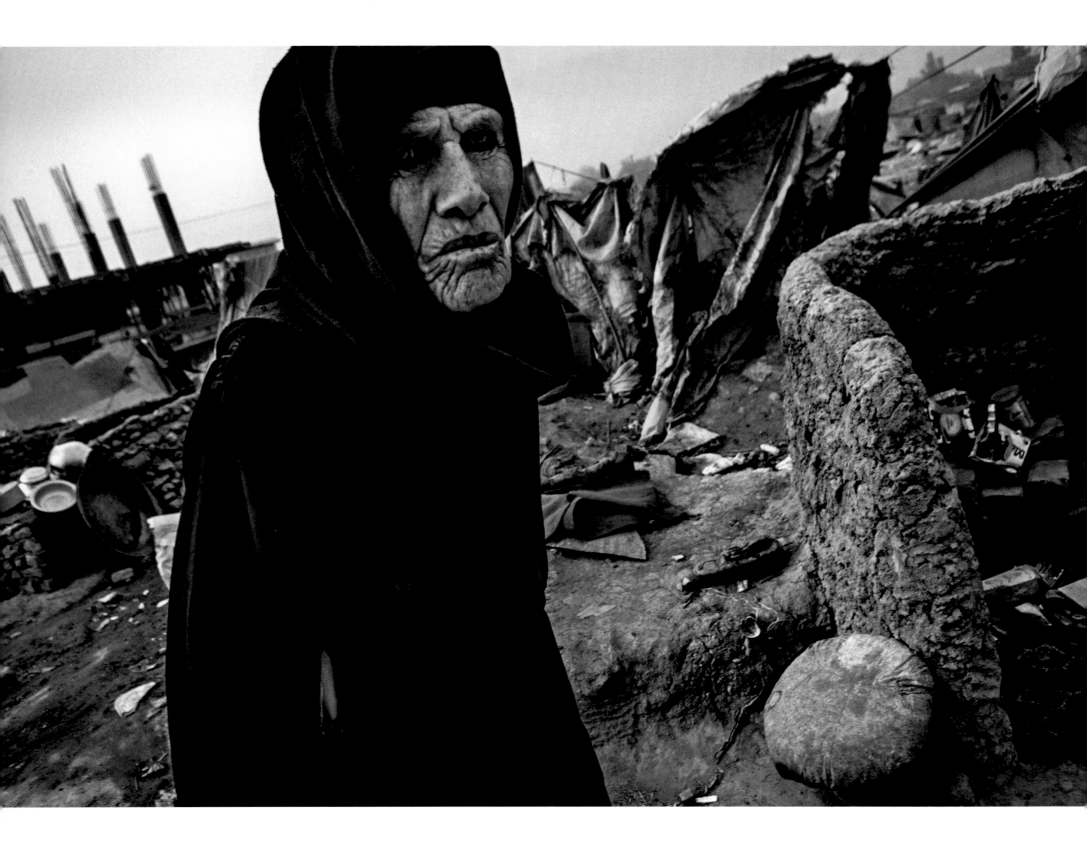

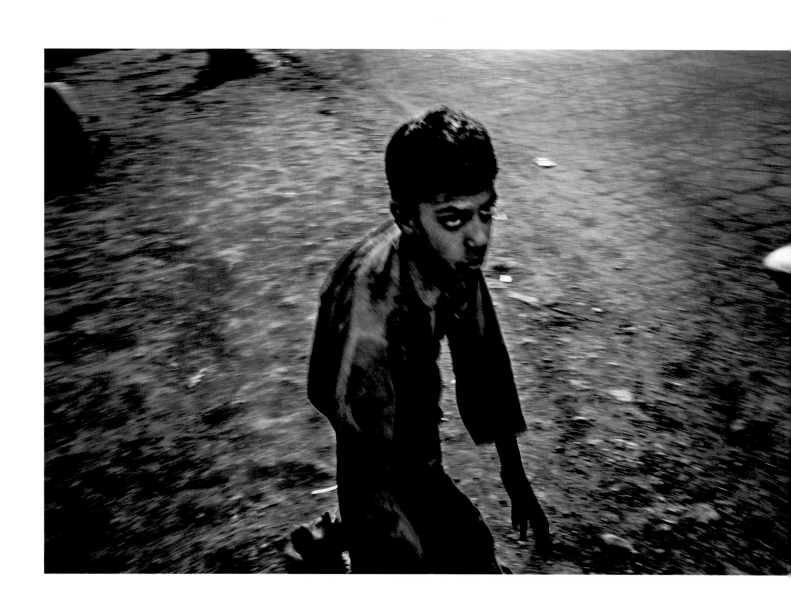

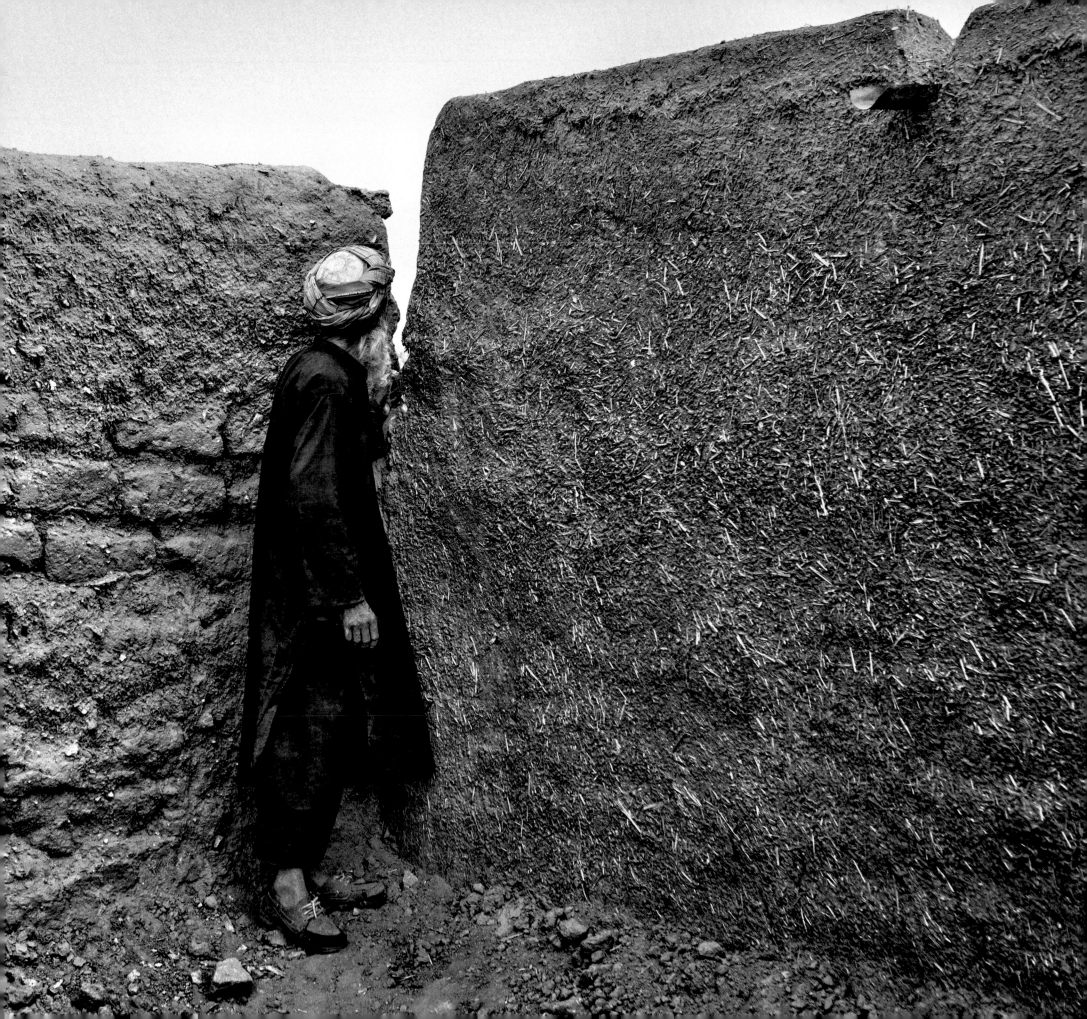

BIOGRAPHY

ZALMAÏ discovered his passion for photography at a very young age in Kabul, Afghanistan, where he was born. After the Soviet invasion in 1980, ZALMAÏ relocated to Lausanne, Switzerland, soon becoming a Swiss citizen. There, ZALMAÏ pursued combined studies at the School of Photography of Lausanne and the Professional Photography Training Center of Yverdon. Upon completing his studies, he began to work as a freelance photographer. Assignments took ZALMAÏ around the world, eventually leading him back to Afghanistan. There, he began documenting the ongoing war and plight of the Afghan people, a continuing project from which the images in this book are drawn.

ZALMAÏ's work has been extensively exhibited at museums, galleries universities and cultural centers around the world. His photographs have been awarded numerous international prizes, including the Visa D'Or from the Visa Pour L'Image Photojournalism Festival and a Getty Images grant. Among many other leading international media outlets, ZALMAÏ's work has been published by the *New York Times Magazine*, *TIME*, the *New Yorker*, *Harper's*, *Newsweek*, and *La Repubblica*. His work is regularly commissioned by NGOs such as Human Rights Watch, the International Committee of the Red Cross (ICRC), the United Nations High Commissioner for Refugees (UNHCR), and the United Nations Office on Drugs and Crime (UNODC).